IMAGES

of America

BRANCH BROOK PARK

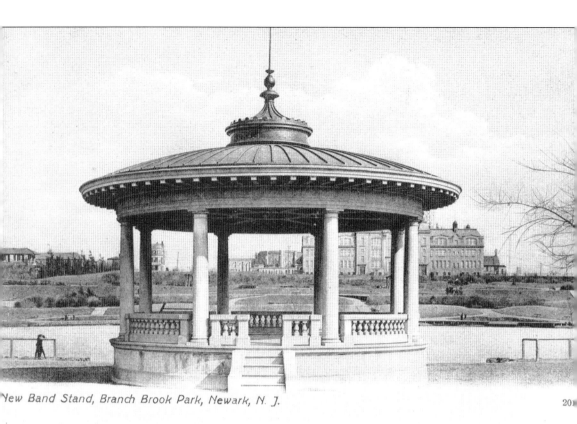

New Band Stand, Branch Brook Park, Newark, N. J. 20

The bandstand in Branch Brook Park was a popular destination for concerts. It was located on the western shore of the lake in the Southern Division, in the shadow of the Park Avenue Bridge. This 1906 postcard indicates that this is the "New Band Stand," suggesting that there may have been an earlier structure.

On the cover: In the 1920s, the Concert Grove boat landing in the Southern Division was a popular site for toy boat launchings, which were sponsored by the Essex County Park Commission. This photograph also shows the bandstand with park benches already lined up for a concert. (Courtesy of the Newark Public Library.)

IMAGES
of America

BRANCH BROOK PARK

Kathleen P. Galop
and Catharine Longendyck

ARCADIA
PUBLISHING

Published by Arcadia Publishing
Charleston SC, Chicago IL, Portsmouth NH, San Francisco CA

Printed in the United States of America

Library of Congress Catalog Card Number: 2007922284

For all general information contact Arcadia Publishing at:
Telephone 843-853-2070
Fax 843-853-0044
E-mail sales@arcadiapublishing.com
For customer service and orders:
Toll-Free 1-888-313-2665

Visit us on the Internet at www.arcadiapublishing.com

To my mother, Helen; my husband, Philip; my niece Holli, and to the memory of my father, John, for all the wonderful times we enjoyed in Branch Brook Park.

—*Kathleen*

To my father, Elmer, my first tennis partner, who enjoyed so many rounds of golf at Hendricks Field, and my mother, Alice, who made sure that our Easter memories were recorded under the cherry blossom trees in Branch Brook Park.

—*Catharine*

CONTENTS

ACKNOWLEDGMENTS

A question about Tiffany Falls in Branch Brook Park led to a conversation about the park and a query whether we should write a book about our beloved park. Just like that, two friends, friendly rivals on the Branch Brook clay courts, were sharing our memories, family photographs, and those of our friends and remembering how tennis brought us together in high school days.

Our first acknowledgment goes to Branch Brook Park for inspiring us and for giving us beauty in the most unexpected places. We are Newarkers and see the park in a very special light. We agree that the park is most magnificent in the fall, despite all the cherry blossom publicity. In winter, we see the park right through to its bones, and they are strong. The park gives us strength and never fails to renew us.

Special thanks go to the Newark Public Library, its director, Wilma Grey, and staff of the Charles F. Cummings New Jersey Information Center, particularly George Hawley, Brad Small, James Osbourn, Ralph Tohlin, and James Lewis. They enthusiastically embraced our idea for this book and shared their knowledge with us. The Newark Public Library was extraordinarily generous in providing images for this book, including the cover photograph.

The park's story cannot be told without assistance from the County of Essex. Particular thanks to Essex County executive Joseph N. DiVicenzo Jr. and members of his staff, including Phil Alagia, Joyce L. Goldman, Anthony Puglisi, and Ana Santos. The Essex County Parks Historic Documents Library was a tremendous resource, and we thank parks director Daniel K. Salvante; Joseph Lanzara, parks archivist; and Kathy Kauhl, archive consultant.

The Branch Brook Park Alliance, through its cochair Barbara Bell Coleman; its vice chair James P. Lecky; and its landscape architects, Faye Harwell, American Society of Landscape Architects (ASLA) project director, and Brad Garner, ASLA, from Rhodeside and Harwell of Alexandria, Virginia, provided materials for this book.

We thank the following friends for historical information and family photographs: Alice MacMunn Burke, Joseph Calaminici, Constance W. Crane, Elizabeth Del Tufo, Joyce Fernicola, Howard Goldfarb, James W. Lecky, Mary Jo McDonough, and Christine L. Napolitano.

The Newark Museum and the New Jersey Historical Society made their collections available to us, and we received assistance and support from Carol Baron, Jane McNeill, Dr. Clement A. Price of Rutgers University, Kevin Moore of the Weequahic Park Alliance, and Mark Tronco of the Forest Hill Community Association. The Archives of the Newark Cherry Blossom Festival were a treasure trove for this book.

Without the support and encouragement of our families, we could not have undertaken the writing of this book.

INTRODUCTION

We were yesterday shown certain lands in the vicinity of Newark, and upon such superficial examination of them as we have since made, we have now, at the request of your Executive Committee, to express an estimate of their fitness to be taken up for a Park.
—Olmsted, Vaux and Company, Report on a Site for a Park at Newark, 1867

The Report strikes me very favorably indeed, and I have no doubt will prove satisfactory to all the Commissioners.
—Letter from Daniel F. Tompkins, Secretary of the Newark Park Commissioners to Frederick Law Olmsted, October 11, 1867

Branch Brook Park is located in Newark, one of the most densely populated cities in the country. Despite the surrounding urbanization, the park has become one of the most beautiful and cherished open public spaces, serving as the backdrop for quiet moments of reflection and active recreation and providing an opportunity to experience all the seasons of nature and unparalleled scenic vistas. It renews one's spirit better than any place around. The park has been a constant in the lives of millions since 1895, maturing and changing and yet always staying the same. The constancy of Branch Brook Park is really the story of this book.

Branch Brook Park did not just happen. As you enjoy its open meadows surrounded by century-old oaks, fish in its tranquil lakes, play a tennis match, and stroll through a flurry of cherry blossom petals, know that this magnificent urban park was put together with a vision and a design.

The vision came in the 1860s from the Newark park commissioners who wanted to provide public grounds for recreation and relaxation open to all citizens. The commissioners were looking to establish "a noble Park in the vicinity of a flourishing city like Newark . . . affording the means of healthful enjoyment to every class of our citizens that may feel disposed to partake of its benefits."

The recommendation of a suitable site for Branch Brook Park came from the firm of Olmsted, Vaux and Company of New York. Frederick Law Olmsted and Calvert Vaux had already completed the designs for New York's Central Park and Brooklyn's Prospect Park. The Newark park commissioners selected this premier landscape architecture firm to lay the groundwork for Branch Brook Park. Their "Report on a Site for a Park at Newark" was submitted to the city on October 5, 1867. The 140th anniversary of this 1867 report is celebrated in this book. Publication of the 1867 report served as the foundation for the development of Branch Brook Park. This milestone event provides the opportunity to look back at the original vision and

designs for the park and show how they have evolved and matured into the Branch Brook Park that we experience today.

The 1867 report discusses how the design intent behind the great public parks of Europe, such as Hyde Park, the Phoenix, and the Prater, influenced the work of Olmsted and Vaux. This acknowledged influence provided the framework desired by the City of Newark to create "a noble Park." Olmsted and Vaux further articulated their philosophy that "the central idea of a large public park is manifestly that of a work of art . . . designed at the outset as all other works of art are designed with the intention of producing, through the exercise of the natural perception, a certain effect upon the mind and the character of those who approach it." Their intent was to create a total environment and experience that would be available to all residents of the city. When selecting the site, accessibility to the public and the existing topography were critical considerations. After visiting several locations, Olmsted and Vaux recommended land that today comprises the Southern and Middle Divisions of the present-day Branch Brook Park. Thus the park's boundaries were drawn by our nation's master park builders more than 140 years ago.

With the 1867 report in hand, Newark's business leaders recommended purchasing 700 acres in the northern section of the city for over $1 million. Such a large expenditure required the approval of the New Jersey state legislature, but it was not forthcoming. The boards of trade of Newark and the Oranges kept alive the idea for a "Park at Newark." Acquiring and dedicating land for public park purposes was such a new idea in the late 1860s that it took another 27 years to move ahead with the plans for Branch Brook Park. Finally in 1894, the state legislature enacted a law providing for a commission to study and report on the advisability of establishing a county park system. Within a year of the commission's report, the state legislature enacted precedent-setting legislation providing for the creation of the Essex County Park Commission and empowering the commission to create a countywide park system—the first such commission and park system in the country. Gov. George T. Werts signed the County Park Commission Act into law on March 5, 1895. One of the very first actions of the new commission was to plan the groundbreaking for Branch Brook Park on June 15, 1895—the park's time had now come.

Land identified in 1867 by Olmsted and Vaux as suitable for a "Park at Newark" included 60 acres surrounding the city reservoir. The city gifted this land to the park commission in 1895, and in the words of the park commissioners, it became "the center of the park system." Work on the park proceeded immediately in phases, beginning with the reservoir land in the area referred to as the Southern Division (whose present-day boundaries start at Route 280 and continue north to Park Avenue). Work then proceeded on the Middle Division, which extended from Park Avenue to Bloomfield Avenue, and then into the Northern Division, running north to Heller Parkway. It was not until the 1920s when sufficient land was acquired north of Heller Parkway that the park commission was able to develop the extension and continue the park into Belleville along Mill Street and the Second River. Today the park includes 359.72 acres, 36.61 acres of waterways, and extends two miles in length.

Branch Brook Park is an almost totally man-made creation that relies upon nature to dress it up. These pages tell the story of how the park came to be built in this northern section of Newark, and how land was acquired to extend the park all the way to Belleville. The designs for the landscape and the plantings are presented. Pictures detail how recreation needs have evolved, how citizens experience the beauty of the park, and how viewing the flowering cherry blossom display became a springtime ritual. Whether you view the park as an "oasis of greenery," a place to escape the stresses of a busy life, or a place to hit a tennis ball or to pitch a no-hitter, you may discover that the park is all of these at the same time. Go back through your memories in this visual journey through Branch Brook Park, and you will see the park again for the first time.

One

A MOSIAC OF MEMORIES

The central idea of a large public park is manifestly that of a work of art – of a peculiar character undoubtedly, but nevertheless designed at the outset as all other works of art are designed, with the intention of producing, through the exercise of the natural perception, a certain effect upon the mind and the character of those who approach it.
—Olmsted, Vaux and Company, Report on a Site for a Park at Newark, 1867

Branch Brook Park is a work of art. Memories of moments in the park and the images they convey give special meaning to the words of Frederick Law Olmsted and Calvert Vaux taken from their "Report on a Site for a Park at Newark."

Memories of Branch Brook Park include summer days boating on the lake; walks on its paths with the sun filtering through the leaves; daydreaming at lake's edge with a friend; the grandeur of Barringer High School with the formal gardens spilling down the hillside; stone bridges along the wandering brook, each bridge different, unique, and artistic in its own way; the Prudential Lions standing sentinel along the lake; Chrysanthemum Shows in the greenhouses with a fragrance and beauty that seem everlasting; the spires of a cathedral reaching into the clouds; bundling up for a winter walk with the dogs; the stately Ballantine Gateway welcoming visitors to the open meadow to picnic, sunbathe, or organize a game of football or soccer; and the return of spring as the first bloom of forsythia along the Second River heralds the arrival of the cherry blossoms. Does not everyone have a picture taken in springtime finery in front of a cherry blossom tree?

Is Branch Brook Park a work of art? Has the park had a certain effect upon those who visit it? Is there any way to describe it without painting a visual picture in colors, tones, and textures? A mosaic of images from the park is presented in the first chapter as a reminder of times spent in the park or an invitation to visit it for the first time.

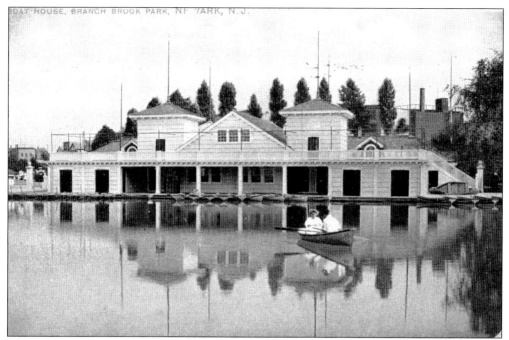

This 1909 postcard pictures the park's boathouse in the Southern Division. This elegant structure replaced a more rustic boathouse built earlier on the same site.

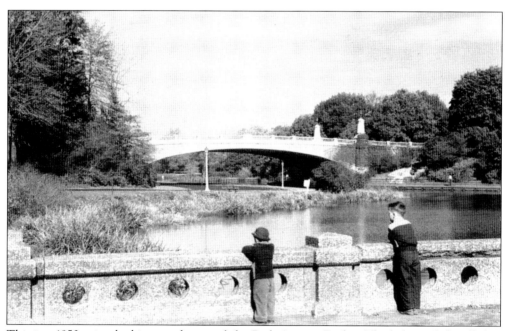

This is a 1950s view looking north toward the Park Avenue Bridge. The balustraded wall that the boys are leaning on shows some of the detail of the boat landing in the area where the bandstand formerly stood.

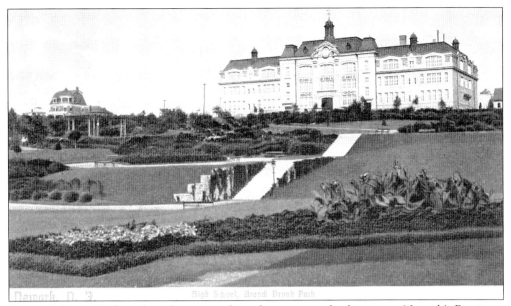

Some of the park's formal gardens were planted on terraces leading up to Newark's Barringer High School. The promenade arbors are clearly visible to the left on this 1908 postcard.

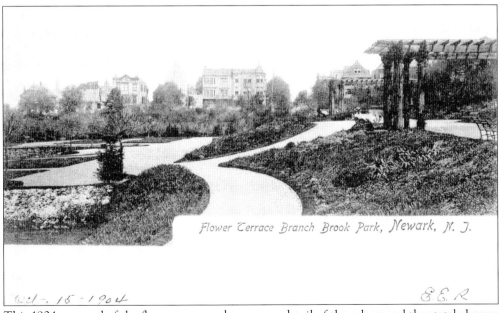

Flower Terrace Branch Brook Park, Newark, N. J.

This 1904 postcard of the flower terraces shows more detail of the arbors and the stately homes along Park Avenue in the background.

This unique stone bridge over the brook in the Northern Division shown on this 1906 postcard is a characteristic example of Olmsted park design. This is just one example of many stone bridges found along the waterway, each built in a different style.

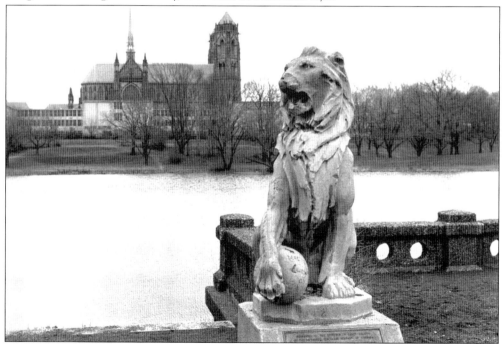

One of the most memorable scenes in the park is that of the twin Prudential Lions at lake's edge. Looking eastward across the lake, one sees the silhouette of the national historic landmark Cathedral Basilica of the Sacred Heart.

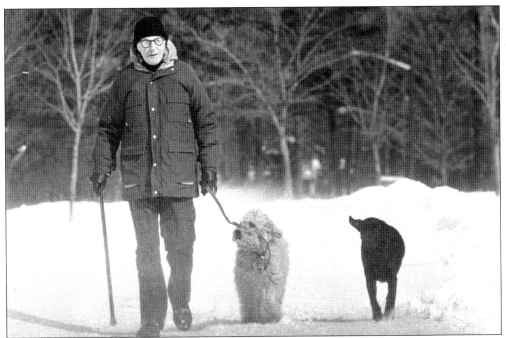

Bundled against the February 1985 elements, John Burke takes a winter walk in Branch Brook Park with his dogs Kitty and Shawn. Burke was the father of Elizabeth Del Tufo, dedicated Newarker and advocate for Branch Brook Park.

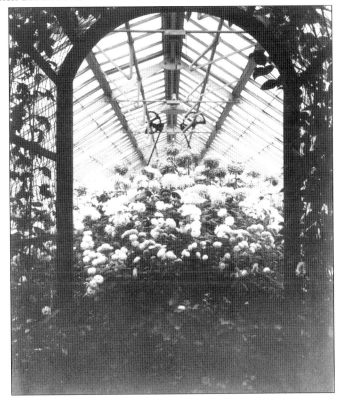

The Chrysanthemum Show was held each fall in the greenhouse in the park's Northern Division. The popular event attracted many visitors and became a favorite of garden clubs throughout the area.

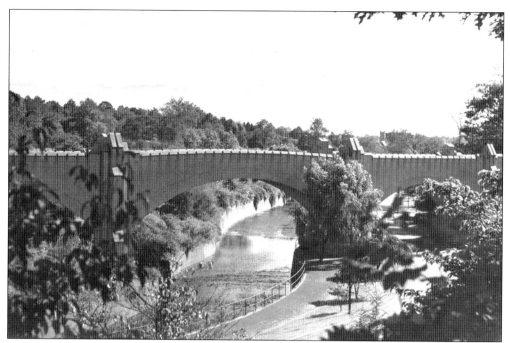

This dramatic pedestrian bridge was completed in 1931 and extends 272 feet across Mill Street and the Second River from the Tiffany factory in Newark to the Belleville section of the park.

"They're so soft and fluffy, it reminds you of cotton."

Elizabeth Del Tufo is portrayed conducting a cherry blossom tour in Kay Kato's column "In the Pink," in the May 4, 1980, *Sunday Star-Ledger*. Commenting on the park's future, Del Tufo reflects, "The beauty and tranquility of landscapes are quite fragile . . . the Park must be protected by those who value those qualities." (From *Park Art with Pad & Pencil in the Parks for 31 Years* by Kay Kato, 1999. Used with permission of Donning Company Publishers.)

Two

AMERICA'S FIRST COUNTY PARK

There will result in the City of Newark, a park in many respects unique and of special charm.
—John Bogart and Nathan F. Barrett,
Landscape Architects and Engineers Report, January 1, 1897

*It should always be borne in mind that the park is intended
primarily for the enjoyment of people in it.*
—Olmsted Brothers,
Landscape Architects' Report, December 14, 1899

When the Essex County Park Commission was created in 1895, only 25 acres of parkland existed in the county, consisting primarily of plots with monuments to national heroes. Branch Brook Park became the first park built in Essex County and carries the distinction of being America's first county park.

Intending to create a countywide system of parks and parkways, in 1895 the park commission retained John Bogart and Nathan F. Barrett, Landscape Architects and Engineers, to develop this concept. Bogart and Barrett proposed a formal park with terraces and elaborate gardens set amid dramatic structures and bridges. Land and houses adjacent to the city reservoir were acquired, streets were vacated, buildings were razed, and the creation of Branch Brook Park began.

Even as work on the Southern Division was underway, on August 22, 1898, the park commissioners, for design and economic reasons, hired the Olmsted Brothers to complete the Southern Division and to create new plans for the balance of the park. John Charles Olmsted is credited with being the guiding force behind the design of Branch Brook Park. North of Park Avenue, the park reflects the Olmsted tradition of naturalistic park design, with the Middle Division providing a transition from recreational pursuits to the pastoral landscapes of the Northern Division. The park extended northward as large swaths of land were acquired by gift or purchase from some of Newark's prominent families with estates in the Forest Hill section of the city.

Expansion of the park north of Heller Parkway into the extension did not occur until the 1920s because land was unavailable. A notable gift of land from Tiffany and Company filled out the park along the Second River.

HISTORICAL FIRST RIVER, NEWARK, N. J.

FORMED BY THE CONFLUENCE OF MILL BROOK AND BRANCH BROOK AT A POINT NEAR THE SOUTHERN EXTREMITY OF BRANCH BROOK PARK, FIRST RIVER TUMBLED EASTWARD THROUGH A VALLEY PARALLELING EIGHTH AVENUE, FLOWED UNDER THE STONE BRIDGE AT BROAD STREET NEAR BLOOMFIELD AVENUE TO JOIN THE PASSAIC RIVER AT CLAY STREET. IN 1863, IT WAS PARTIALLY ARCHED OVER. BY 1891, THE ENTIRE FIRST RIVER WAS COVERED FROM SIGHT. THOUGH NOW HIDDEN, IT STILL FLOWS TO THE SEA.

THIS WAS THE FIRST MAJOR STREAM THE FOUNDING FATHERS SIGHTED AS THEY SAILED UP THE PESAYAK IN MAY, 1966.

THROUGH THIS LAND ROAMED WOLVES, BEAR, COPPERHEADS AND RATTLESNAKES. THE TOWN MEETING OFFERED TWENTY SHILLINGS TO "ANY MAN THAT WOULD TAKE PAINS TO KILL WOLVES," TEN SHILLINGS FOR THE HEAD OF EVERY GROWN BEAR AND FIVE SHILLINGS FOR THE HEAD OF A CUB.

IN 1671, NEWARK'S FIRST INDUSTRY — THE GRIST MILL — WAS DEVELOPED ON THIS RIVER BY ROBERT TREAT. HERE THE BROWNSTONE QUARRYING INDUSTRY BEGAN ABOUT 1720.

BY 1836, THE FIRST RIVER VALLEY WAS HUMMING WITH IRON FOUNDRIES, AND FACTORIES FOR THE MAKING OF SADDLE HARDWARE AND CUTLERY, THUS GIVING FACTORY STREET AND CUTLER STREET THEIR NAMES.

FROM 1840 TO 1845, THE NEWARK AQUEDUCT COMPANY DEVELOPED A SYSTEM OF SPRINGS, DRIVEN WELLS AND PIPE LINES IN THE VALLEY OF THE BRANCH BROOK.

IN 1860, THE CITY OF NEWARK BOUGHT THE NEWARK AQUEDUCT COMPANY.

IN 1897, THE ABANDONED RESERVOIR AND THIRTY ACRES BORDERING THE STREAM WERE GIVEN BY THE CITY OF NEWARK TO THE ESSEX COUNTY PARK COMMISSIONERS FOR THE CREATION OF BRANCH BROOK PARK.

FIRST RIVER PLAYED THE ROLE OF A PIONEER IN THE INDUSTRIAL DEVELOPMENT OF NEWARK.

ERECTED BY THE SCHOOLMEN'S CLUB WITH THE
ASSISTANCE OF THE
PUPILS OF THE NEWARK PUBLIC SCHOOLS
MAY 17, 1957

This plaque presents an interesting history of what previously existed on land that became Branch Brook Park. Installed at McKinley School on Eighth Avenue, one block from the park, the plaque was dedicated on May 17, 1957, by the Schoolmen's Club of Newark. The goal of this organization was "to inspire the future with the record of the accomplishment of the past." The club celebrated Newark Day each year by placing a historical plaque in a prominent location.

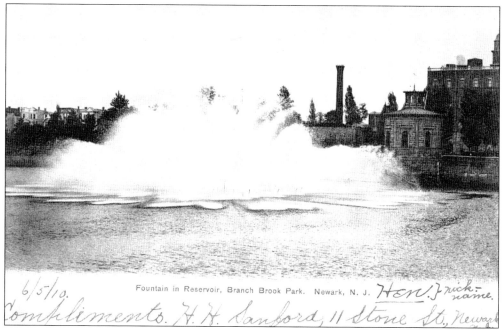

6/5/10. Fountain in Reservoir, Branch Brook Park. Newark, N. J. *Here.? nick-name.*

Compliments. H. H. Sanford, 11 Stone St., Newark

This elaborate fountain in the reservoir was the largest water fountain in the world at that time. In the background are buildings previously occupied by the Newark Aqueduct Company. The fountain was abandoned in 1915, and the reservoir was later drained. It subsequently became the site of an outdoor ice-skating rink, later replaced by an indoor roller-skating rink.

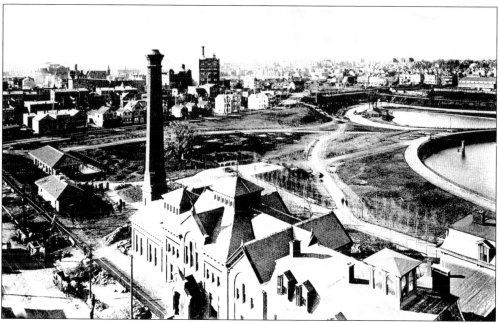

This 1899 aerial photograph of the Southern Division shows the Newark Aqueduct Company structures in the foreground, facing onto Clifton Avenue. To the left of these buildings is the Sand Court Shelter, one of the earliest park buildings, designed by Carrère and Hastings with modifications suggested by the Olmsted Brothers.

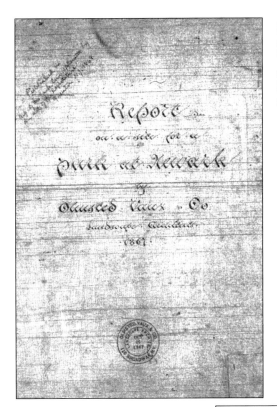

Seen here is the handwritten title page of the Olmsted, Vaux and Company "Report on a Site for a Park at Newark" dated October 1867, obtained from the Manuscript Division of the Library of Congress.

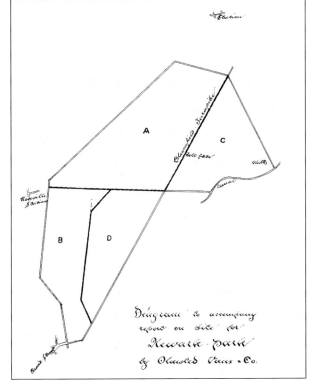

This is a sketch from the above report of land recommended for inclusion in Branch Brook Park. Portions of the sections designated B and D ultimately became part of the Southern and Middle Divisions of the park. None of the land recommended in sections A and C was acquired for the park.

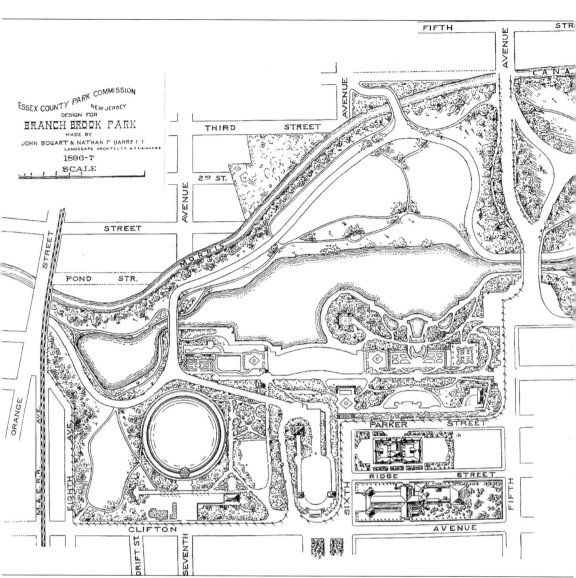

Pictured here is the detailed design for the Southern Division prepared by John Bogart and Nathan F. Barrett, Landscape Architects and Engineers, dated 1896–1897. The formal gardens and terraces on the east side of the lake are clearly visible. The land surrounding the city reservoir is incorporated into this design in the lower left. The footprint of the Cathedral Basilica of the Sacred Heart is shown in the lower right. At that time, Park Avenue was still referred to as Fifth Avenue.

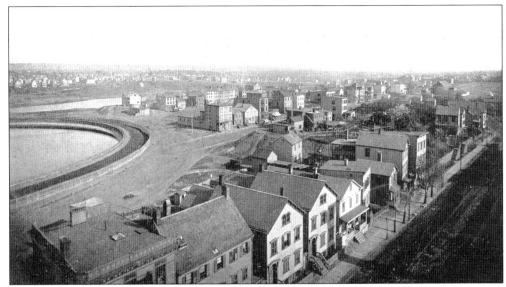

The 1901 Annual Report of the Essex County Park Commission contained these images showing the early development of Branch Brook Park. The 1896 photograph above shows homes along Clifton Avenue, east of the city reservoir, as the park was first being developed. The 1902 photograph below shows the same scene after terraces, gardens, and arbors had been constructed on land previously occupied by those homes. The outline of the city reservoir appears at the far left. On the right, rising above the park, is the new high school, which later became known as Barringer High School.

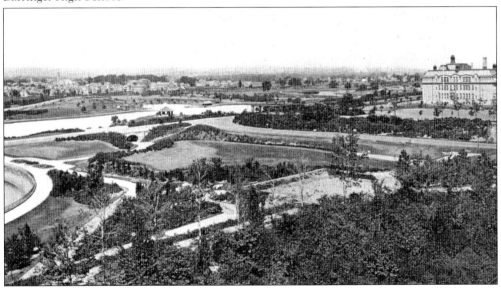

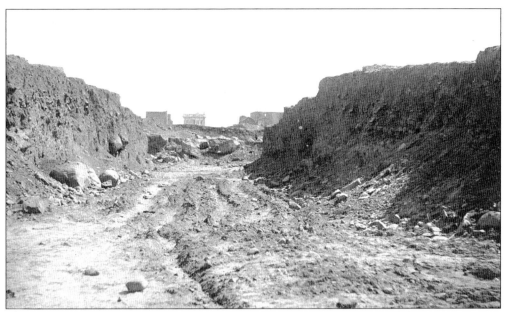

These photographs were also contained in the 1901 Annual Report of the Essex County Park Commission. They demonstrate the extent of construction and earth moving required in the fashioning of the park. The above photograph shows the preparation for construction of the elaborately designed subway that passes under the road in the Southern Division. The photograph below shows the beauty of the stonework in the Carrère and Hastings–designed Subway Arch. The incorporation of this subway feature in the park enabled pedestrians to stroll through the park without interference from traffic on the park roads.

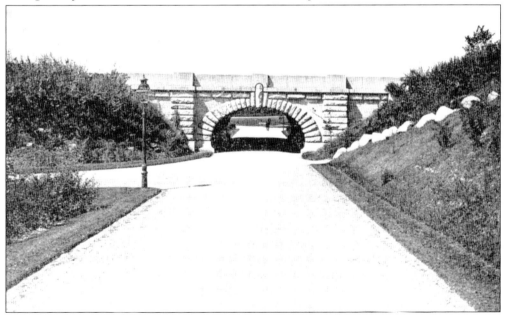

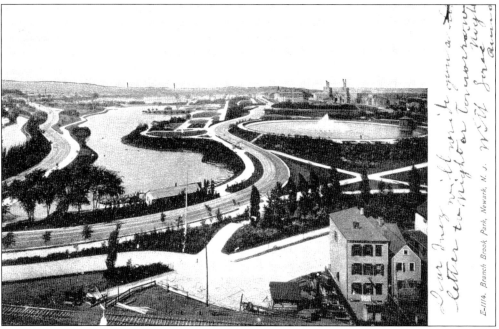

This 1908 postcard provides a commanding view of the Southern Division, featuring the boathouse at lake's edge in the center, the fountain in the reservoir on the right, and the Gothic towers of the cathedral just beginning to rise above the horizon in the right-hand background.

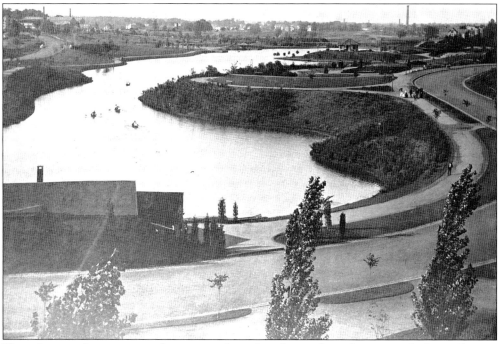

This photograph presents a closer view than that depicted in the postcard above. Boaters are clearly evident on the lake, and there is no indication that the Park Avenue Bridge has yet been constructed. Off in the distance to the right is the Carrère and Hastings–designed Octagon Shelter.

NUMBER | SENT BY | REC'D BY | | CHECK

8

RECEIVED at 5.32 Pm Oct 2 1899

Dated Brookline, Mass

To Wm S. Manning

Madison, N.J.

Would be glad to meet
you if convenient at
Branch Brook Office tomorrow morning
about nine John C. Olmsted

This telegram dated October 2, 1899, was sent by John C. Olmsted of Brookline, Massachusetts, to William S. Manning, park superintendent, arranging for one of Olmsted's many visits to Branch Brook Park. The Olmsted Brothers was retained on August 22, 1898, to serve as landscape architects to the Essex County Park Commission.

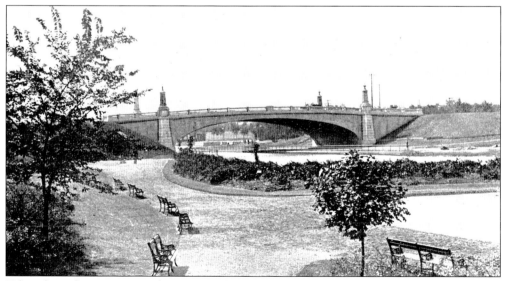

Taken from the 1907 Annual Report of the Essex County Park Commission, this photograph shows the elegance of the Park Avenue Bridge spanning the lake where the former Fifth Avenue existed prior to creation of the park. Time and weather had taken its toll on this magnificent structure, but the County of Essex has now completed a restoration project and installed new lighting on the bridge.

The letter to the left from John C. Olmsted to William S. Manning dated December 16, 1899, evidences the detail with which the Olmsted Brothers handled every aspect of park design. Here Olmsted recommends that "as many of the existing trees as possible" be retained. Olmsted was not as concerned about the quality of the trees as he was with creating shade along the brook in the Northern Division. The 1905 postcard below represents a section of the meandering brook with the shade feature clearly evident. Thus, it would appear that Olmsted's objective was achieved.

Branch Brook Park, Newark, N. J.

24

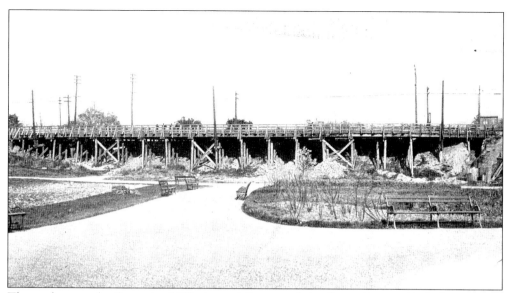

These photographs from the 1907 Annual Report of the Essex County Park Commission present a before and after scene of the Bloomfield Avenue Bridge. This shows once again the extent of construction necessary for the creation of Branch Brook Park. The photograph below presents the beautifully finished bridge with a trolley car traveling west from Newark to the neighboring communities.

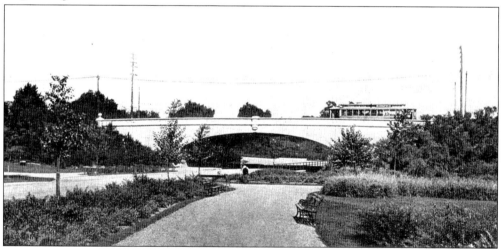

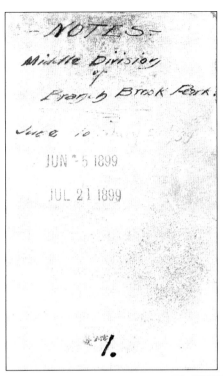

An interesting find in the Essex County Parks System Historic Documents Library was this notebook record by a construction supervisor. The cover indicates that the work recorded was done in the Middle Division from June 5 to July 21, 1899. The pages selected for illustration below are dated Saturday, July 8, 1899. The page on the left lists the workforce on site that day. The page on the right presents a sketch of work at the intersection of Lake Street and Bloomfield Avenue. It is interesting to note that one blacksmith and one blacksmith's helper were on the job in the morning, with one team of horses for "ploughing."

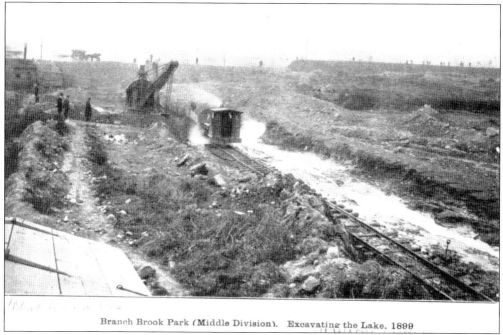

Branch Brook Park (Middle Division). Excavating the Lake. 1899

Work in the Middle Division also required laying down tracks for a work train as excavation of the lake proceeded in 1899. Heavy equipment like that shown above was used throughout the park. The Middle Division has traditionally been the location for the most active recreational pursuits. The photograph below, taken from the 1901 Annual Report of the Essex County Park Commission, shows the finished lake. Families with young children are enjoying informal sports in the foreground; in the background, there appears to be more organized sports events. This is the same area where the County of Essex has rehabilitated the Middle Division ball fields as shown on page 124.

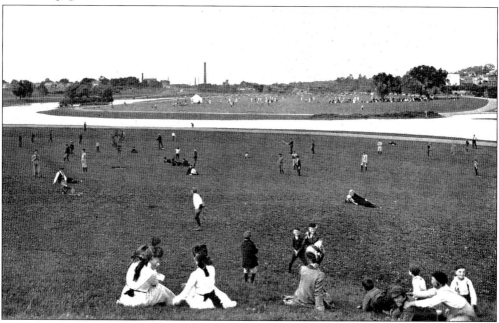

April 28, 1899.

Dear Sir:

We beg to remind you that the plans of the Ballantine gateway which were left with the Commission to be shown to Mr. Ballantine were the original drawings. We shall be glad to have you return these as soon as you are entirely through with them as Mr. Olmsted has requested us to send him a copy of the plans, and we are unable to do so as we have no copies.

Yours truly,

[signature]

To Alonzo Church, Secy.,
Essex County Park Commission,
Newark, N. J.

Carrère and Hastings of New York City designed the Ballantine Gateway entrance to the park in the Northern Division. This letter dated April 28, 1899, to Alonzo Church, secretary of the Essex County Park Commission, discusses the original drawings submitted for this entrance and requests their return for review by John C. Olmsted. Pictured below is the completed Ballantine Gateway at the corner of Lake Street and Ballantine Parkway, formerly Chester Avenue. The gates were built at a cost of $27,895.25. To complement the landscaping at this entrance, the Prospect Heights Land and Improvement Company donated a quarter of an acre of land. The two one-story buildings of brick and limestone are connected with a heavy wrought iron entrance gate. This photograph shows the dramatic effect one sees approaching the gateway.

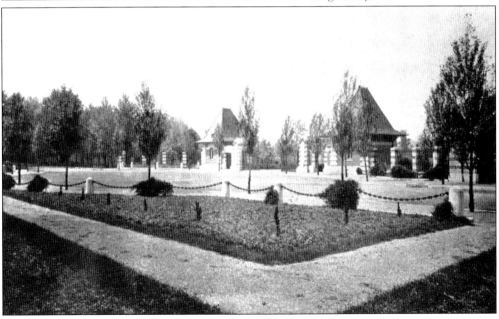

Robert F. Ballantine was the scion of a prominent Newark family whose fortune derived from the brewing industry. He served as a member of the Essex County Park Commission from December 1901 to December 1905. In addition to donating funds for the gateway, the Ballantine family donated extensive landholdings for the Northern Division of Branch Brook Park.

FRANKLIN MURPHY

Franklin Murphy was appointed one of the original members of the Essex County Park Commission in 1895. When he became governor of the state of New Jersey in 1902, he resigned from the park commission but returned when his term as governor was completed in 1905. He was clearly one of the more prominent citizens to have served the Essex County Park System.

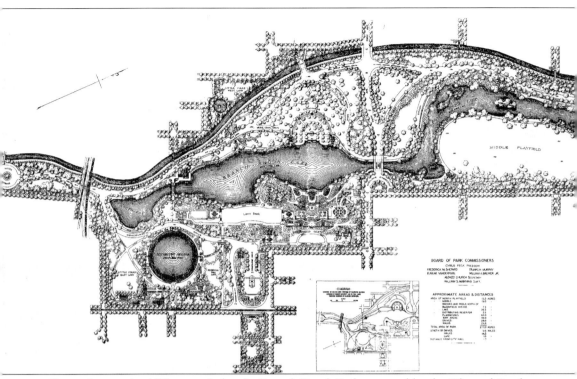

Shown here is the 1901 general plan for Branch Brook Park prepared by the Olmsted Brothers, Landscape Architects. This plan shows the progression of design from the very formal Southern Division, through the transitional Middle Division, to the more pastoral and scenic Northern Division. The park extended from Sussex Avenue on the south to Fredonia Avenue (now Heller Parkway) on the north. Total acreage for this plan was 277 acres with 5.6 miles of drives and

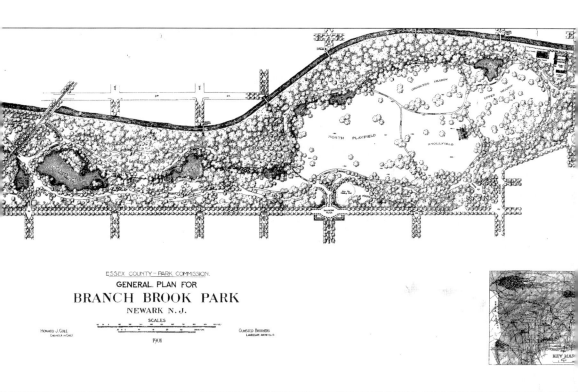

ESSEX COUNTY – PARK COMMISSION.
GENERAL. PLAN FOR
BRANCH BROOK PARK
NEWARK N. J.
SCALES

HOWARD J. COLE
ENGINEER IN CHIEF

OLMSTED BROTHERS
LANDSCAPE ARCHITECTS

1901

KEY PLAN

14.3 miles of walks. The insert on the left-hand page of this general plan shows an outline of the John Bogart and Nathan F. Barrett design, which the Olmsted Brothers were instructed to incorporate within their plans. Present-day boundaries of Branch Brook Park extend north of Fredonia Avenue on land that was acquired in the 1920s and is known today as the "Extension."

Prominent in the surrounding Forest Hill neighborhood were Elias G. Heller (left) and Paul B. Heller (right). They served as president and secretary, respectively, of the Forest Hill Association, which owned large tracts of land in the northern part of Newark on the New York and Greenwood Lake Railroad line. The Hellers were substantial landowners in their own right. A portion of the land owned by the Hellers served as the Eastern Terminal of the United States Aerial Mail Service from 1919 to 1921. This field and other Heller land were later included within the Northern Division of the park. Pictured below is the outstanding home of Elias G. Heller on Elwood Avenue, one block from Branch Brook Park.

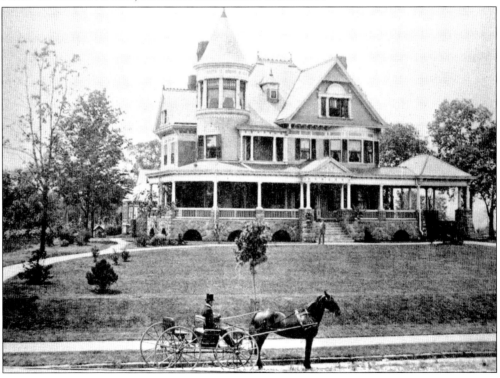

Work in the park advanced into the Northern Division, as shown in these photographs from the 1901 Annual Report of the Essex County Park Commission. Pictured above is a rugged section in the Northern Division before any improvements took place. The transformation from overgrown fields to manicured parklands was dramatic, as shown in the photograph below of curving walkways and elaborate plantings. Detailed planting plans prepared by the Olmsted Brothers were carefully followed in laying out the landscape.

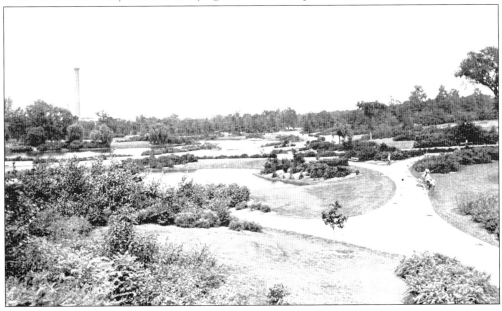

Jasper Crane was among the group of settlers who accompanied Robert Treat in 1666 when "Newark on the Pesayak" was founded. His descendants included Stephen Crane, author of *The Red Badge of Courage*. Other family members held homesteads throughout Newark. On the northern edge of the city was the Isaiah Crane Farm, most of which was sold to Elias Heller, and the land eventually became part of the Extension. In fact, the present tennis courts stand on what was formerly the Crane orchard. The original Crane farmhouse was built in 1760 and is pictured above in a watercolor by S. W. Ward, a relative of Constance Ward Crane. When the Crane farmhouse was torn down, the stones were used to construct the oldest portion of the Forest Hill Presbyterian Church on the corner of Heller Parkway and Highland Avenue, shown below.

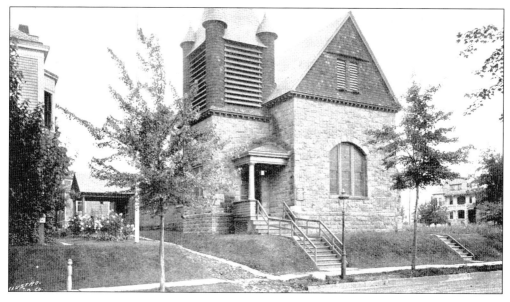

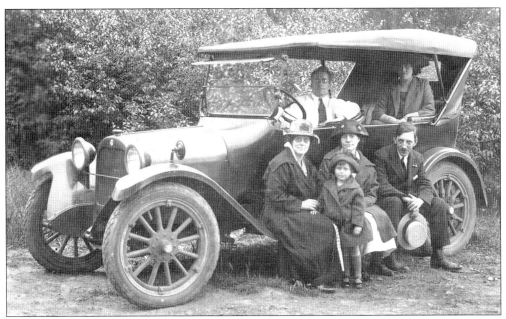

Members of Constance Ward Crane's family in their Sunday best appear to be ready for a drive in the park. Pictured behind the wheel is her father, William Ward Crane, and seated in the rear seat is her Aunt Edna. On the running board are her mother, Beatrice, Constance herself (as a very young girl), her Aunt Bess, and her uncle Stewart. Constance was the last member of the Jasper Crane family to live in Newark and is herself a talented watercolorist.

Tending the cows on the Crane farm is Constance's uncle Stewart. The pasture backed up to the Forest Hill Field Club, and Constance reported that her family would find golf balls scattered in the field. The pasture was bordered on the north by the New York and Greenwood Lake Railroad line.

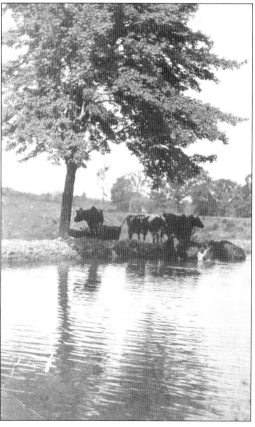

Running the entire length of Branch Brook Park, as seen in the Olmsted General Plan on pages 30 and 31, was the bed of the historic Morris Canal. This canal traveled through northern New Jersey from the Delaware River and terminated at the Passaic River in downtown Newark. The canal was the primary means of transportation for bringing New Jersey's produce and manufactured products to the marketplace. The photograph above shows the Morris Canal near the present-day Clara Maass Hospital, adjacent to the Extension. The photograph to the left with the cows seeking shade under a tree shows how rural this area was in 1914.

The bed of the Morris Canal would serve a new mode of transportation when in the 1920s and 1930s, it became the route of the Newark City Subway, which eventually extended from Pennsylvania Station in downtown Newark to the Franklin Station at Grafton Avenue in Forest Hill. The line has since been converted to a light rail system extending into Bloomfield. Hundreds of commuters utilize this system daily. Pictured to the right is the cover of the City of Newark's 1932 "Contract Plans for the Construction of Section No. 6 of City Railway" between Orange Street and Heller Parkway. Pictured below is a vintage 1960s city subway car as it emerges from the Heller Parkway station, traveling south.

CITY OF NEWARK

NEW JERSEY

DEPARTMENT OF PUBLIC AFFAIRS

Transit Bureau

Contract Plans for the Construction

of

SECTION No. 6

of

CITY RAILWAY

In the bed of the Morris Canal, Between
Orange Street and Heller Parkway,
City of Newark, N. J.

1932

Construction projects from 1928 to 1932 in the Extension proved to be some of the most costly and elaborate within Branch Brook Park. Total construction costs reached $2 million for three concrete arch bridges spanning the Second River to accommodate pedestrians, automobiles, and the railroad. The project also included a large storm sewer and a double concrete retaining wall that was 3,500 feet long. The photograph above of the construction work underway on the automobile bridge details the new concrete retaining walls that in effect channelized the Second River, prevented flooding, and increased the area of usable parkland. The 1944 postcard below shows the same automobile bridge fully landscaped with wide walkways for strolling alongside the river.

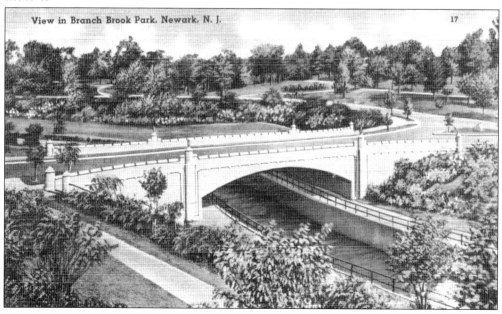

Three

THE VISION IS REALIZED

What artist, so noble . . . as he who . . . sketches the outline, writes the colors, and directs the shadows of a picture so great that nature shall be employed upon it for generations.
—Frederick Law Olmsted Sr.

Work on the park commenced almost immediately after the June 15, 1895, groundbreaking. Earth was transformed into the designs set forth by John Bogart and Nathan F. Barrett and the Olmsted Brothers. The lake was created, and curvilinear carriage roads and walking paths were carved into the land. Almost simultaneously with the heavy construction work, trees and shrubs were planted and the elegant floral gardens of the Southern Division started to emerge. Nothing was left to chance. Everything was planted according to detailed plans that included both native and exotic species, some rarely found in an urban setting.

In the early images shown here, the trees are like twigs and some still unacquired homes continued to populate the parkland. Gradually as pages are turned, the saplings mature into stately century-old oaks, willows, and evergreens. Specimen trees and plantings, including a stand of bamboo in the Middle Division, developed into a truly unique and cohesive landscape. The prominence of park buildings like the Flower Terrace Overlook and the Octagon Shelter was enhanced by the layout of the surrounding flower beds and the lily pond. Park benches were placed along the path. The towers of the Cathedral Basilica of the Sacred Heart were rising alongside the park and serve as the park's most dramatic backdrop today.

Most importantly, the people of the city were coming in large numbers to experience the beauty of the park. On land previously known as Camp Frelinghuysen that had served as the mustering grounds for the 13th Regiment during the Civil War, people were strolling amid the flowers in their Sunday best. Families now gathered for picnics and reunions on land that had been part of the estates of the Ballantine, Clark, Keen, Righter, Taylor, McAndrews, Patterson, and Heller families. The open field comprising so much of the Northern Division had once served as the Eastern Terminal of the United States Aerial Mail Service from 1919 to 1921, until Elias and Paul Heller donated it to the park. Today that field is a favorite site for active and passive recreation pursuits.

In a city where green space has always been at a premium, people have been coming to the park for over a century.

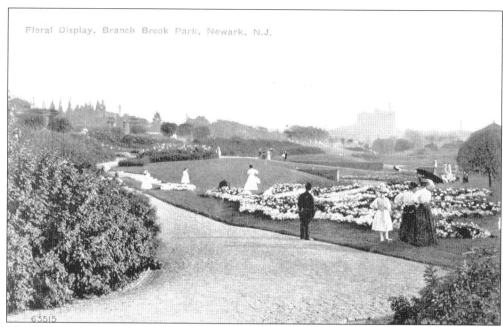

The John Bogart and Nathan F. Barrett design for Branch Brook Park emphasized formal gardens and terraces, with complementing structures. The postcard above shows park visitors admiring the spring floral display. The postcard below gives a close-up view of the Italian Garden.

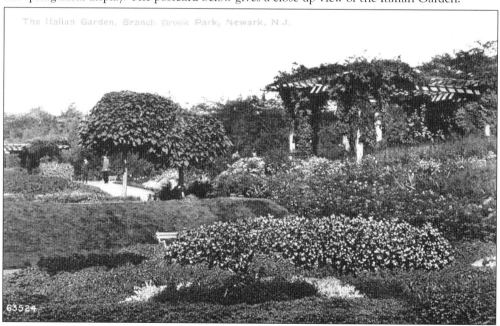

The Italian Garden, Branch Brook Park, Newark, N.J.

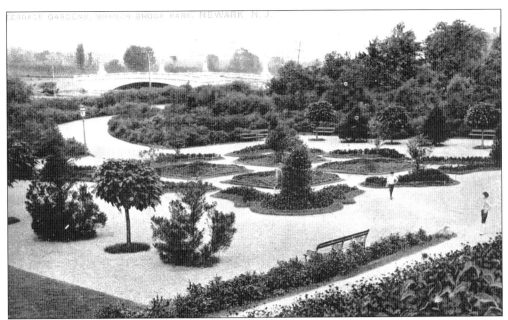

These two photographs record the growth of the garden displays over time. In the image above, a 1908 postcard exhibits the Terrace Gardens several years after their original planting. It contrasts sharply with the photograph below, where the trees and shrubs are small or nonexistent, and an old building on the far right is still standing. The Terrace Gardens were also called the English Garden.

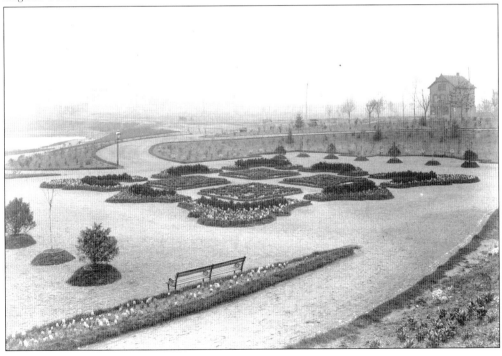

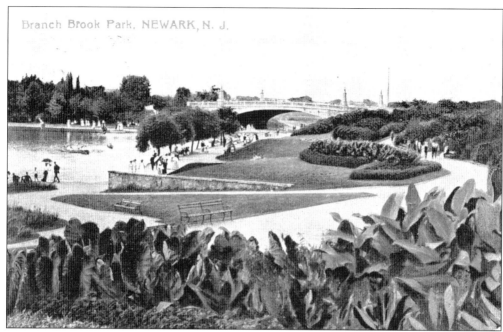

Branch Brook Park, NEWARK, N. J.

The gardens shown in the above postcard display rather exotic foliage in the foreground. The scene in the postcard below is more tranquil.

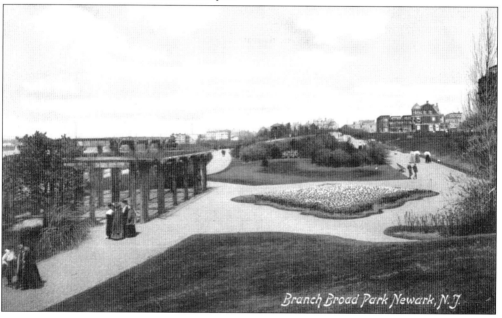

Branch Broad Park Newark, N. J.

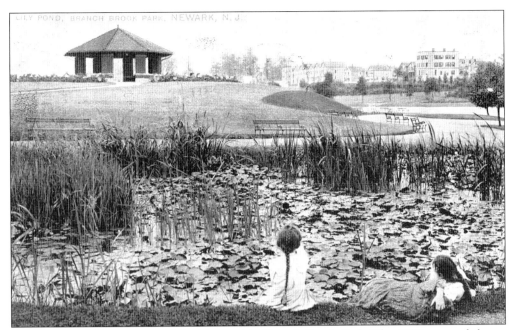

Here are two different views of the lily pond in Branch Brook Park. The 1908 postcard shown above has the Octagon Shelter on Meeker Mound in the background, while the 1948 postcard below shows the lily pond and flower beds against a backdrop of the Cathedral Basilica of the Sacred Heart.

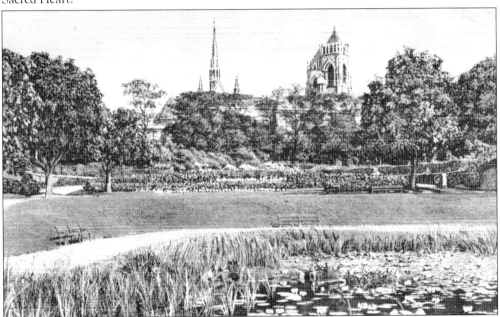

The photograph above affords a wonderful view of the Horseshoe Gardens, with tulips in full bloom.

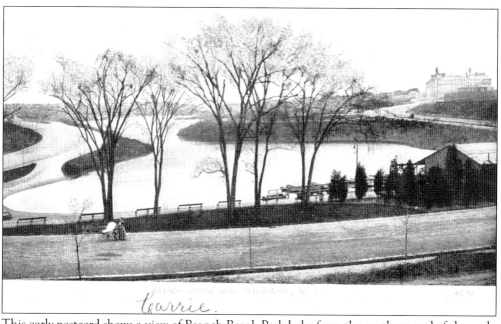

This early postcard shows a view of Branch Brook Park Lake from the southern end of the park. The original rustic boathouse can be seen in the lower right corner.

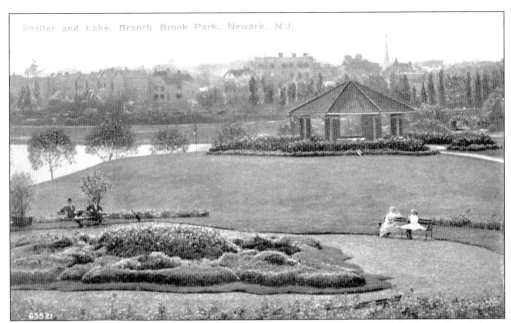

A mother and her daughter take in the lakeside scenery with the Octagon Shelter behind them. The shelter is set on Meeker Mound, which was named for Stephen J. Meeker, one of the original Essex County park commissioners appointed in 1895.

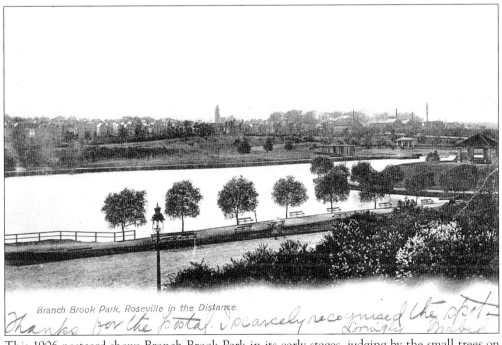

Branch Brook Park, Roseville in the Distance.

This 1906 postcard shows Branch Brook Park in its early stages, judging by the small trees on the near lakeshore and the scarcity of the plantings on the far shore. Note the placement of park benches along the shoreline and one of the original streetlamps in the foreground.

This view of Branch Brook Park faces south of Bloomfield Avenue, according to the 1907 postcard shown above. Rustic wooden fencing similar to that shown here was placed in several locations throughout the park.

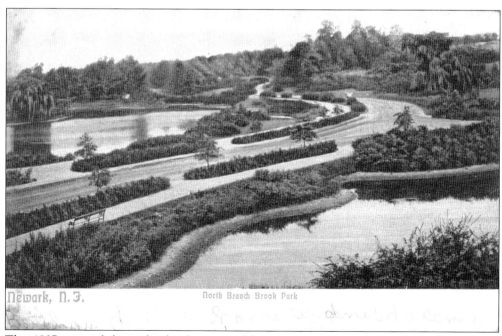

Newark, N. J. North Branch Brook Park

This 1907 postcard shows the development of the Northern Division of the park. Today these waterways are much smaller, and the one on the lower right has been filled in.

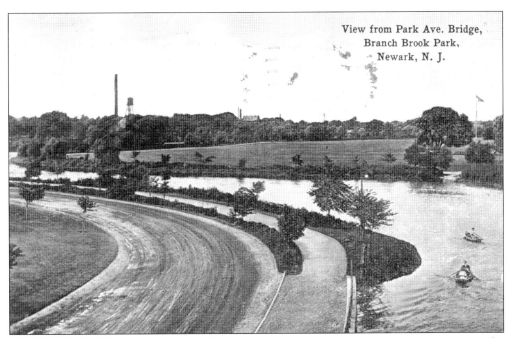

Above is a 1914 postcard view from the Park Avenue Bridge, facing north as one enters the Middle Division. The scenery in this section made this a favorite route for boaters traveling between the two boathouses.

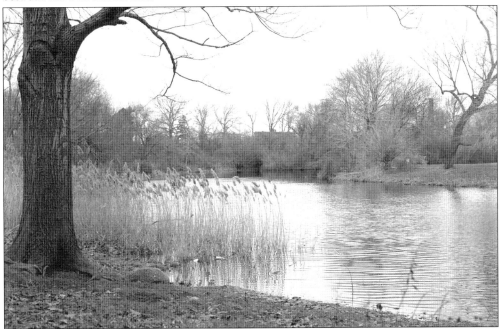

The banks of the stream in the Northern Division in the fall season are shown in this 1970s photograph. The Northern Division was originally designed to be more heavily wooded than the Middle and Southern Divisions. In keeping with the Olmsted concept of park design, there were no formal flower gardens in this section. The brooks and smaller pools in the Northern Division eventually feed into the lake in the Middle and Southern Divisions.

47

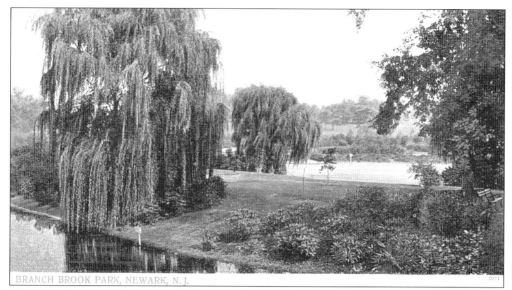

BRANCH BROOK PARK, NEWARK, N.J.

The area shown on the postcard above was known as the Willows and was a popular spot to promenade in the Middle Division. The 1910 postcard below shows Clark's Island, a lushly planted retreat that was reached by a wooden bridge called the Rustic Bridge, seen on the left. Bird watching was popular in the dense forest of this small island. The island was located in an area originally known as Clark's Pond and owned by the William Clark family. Clark was a prominent manufacturer who came to the United States from Scotland and founded the Coats and Clark Thread Company. The Clark Mansion on Mount Prospect Avenue is now home to the North Ward Center.

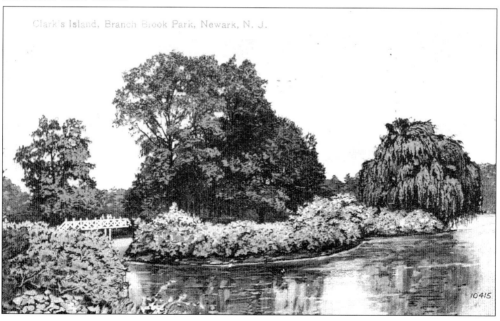

Clark's Island, Branch Brook Park, Newark, N. J.

Pictured above on a 1913 postcard is Midwood Pool in the Northern Division. The 1905 postcard below shows Midwood Drive in the same section of the park. Today one reaches this area by traveling along the West Drive that parallels the waterway and the bed of the former Morris Canal, now the route of the Newark City Subway.

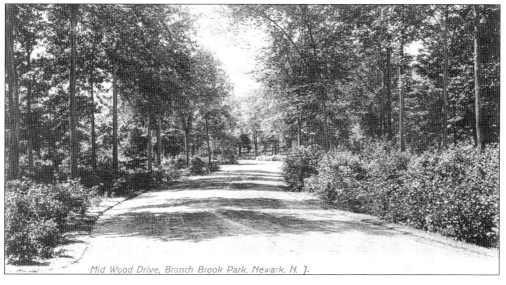

Mid Wood Drive, Branch Brook Park, Newark, N. J.

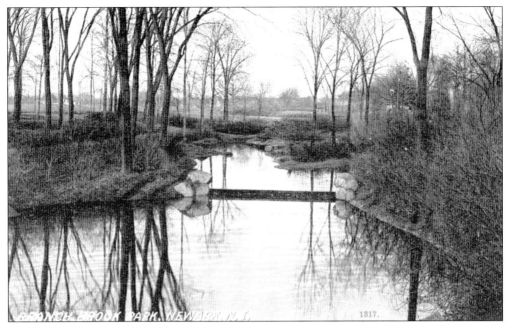

This tranquil scene from a 1910 postcard, above, displays the rural ambiance desired by the Olmsted Brothers in their design of the Northern Division of Branch Brook Park. The same peaceful aura is shown below on a postcard view from one of the stone bridges popularized by the Olmsted Brothers and found in many locations along the brook. These views of the Northern Division are in the general area of the Ballantine Gateway.

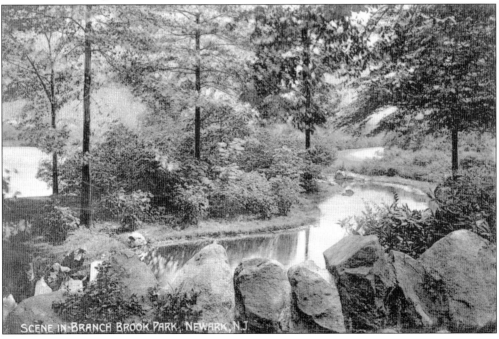

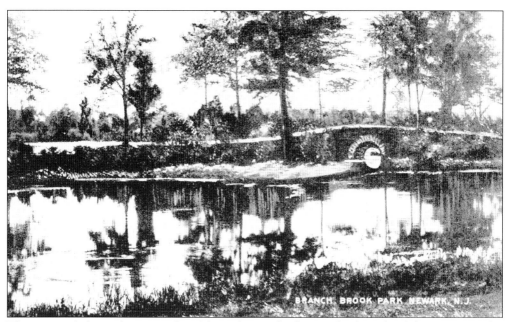

The postcard above shows another Olmsted stone bridge on the far side of the stream in the park's Northern Division. The 1906 postcard below portrays the meandering aspect of the stream in this same area, with another stone bridge in the distance. There are a series of footbridges crisscrossing the brooks in the Northern Division. Although each one is unique, they all have the same design concept. These footbridges survive to 2007, even though the water they cross may be no more than a trickle today.

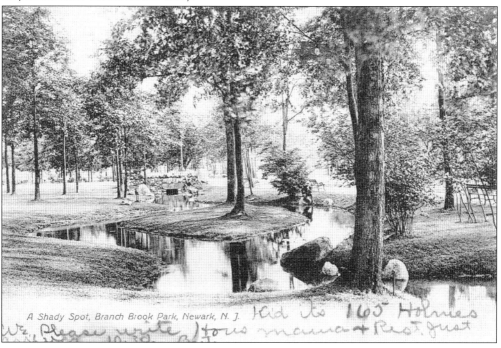

A Shady Spot, Branch Brook Park, Newark, N. J.

51

When Branch Brook Park expanded into the Extension, up to the Belleville border, the park's famous cherry blossom trees were planted along the Second River. This breathtaking photograph by Howard Goldfarb of Milt's Photo in Belleville catches for posterity the magnificence of these plantings.

Pictured here is a truckload of trees waiting to be planted in the Extension. A total of 420 new trees were added to the park's cherry blossom display at that time. These trees were purchased by the Cherry Tree Fund in 1979 as a result of a fund-raising campaign by the Newark Cherry Blossom Festival.

Four

STRUCTURAL ELEMENTS

The Board has completed the subway east of the lake with square fronts in harmony with the surrounding formal garden terraces and straight walks.

—Olmsted Brothers,
Landscape Architects' Report, December 14, 1899

The buildings and structural elements of Branch Brook Park have become almost as significant and memorable as the landscape design itself. They are landmarks in their own right and of a design and a style befitting the significance of "America's first county park." Conceptualized by the landscape architects, in most instances their designs were the product of the firm of Carrère and Hastings, noted architects of the New York Public Library.

Several boathouses have anchored the southern tip of the lake, ranging from simple to quite elaborate, but all providing the opportunity for boating and skating. The Sand Court Shelter, which originally housed a sandbox and a covered place for children to play, is one of the oldest structures in the park. The open-air Octagon Shelter, which no longer stands, was the place to relax on elevated ground, overlooking the lake and surrounding flower gardens.

Bridges are some of the most notable features of the park's built environment. Dozens of bridges are scattered throughout the park, some spanning the roads, some built as subways under the roads, and some appearing to be casually made of field stones from a pasture, which provide vantage points to experience the park's vistas from interesting angles.

Some structures were as simple as a prefabricated Sears, Roebuck and Company maintenance building in the Extension and as grand as the magnificent Ballantine Gateway given to the park in 1899 by Robert F. Ballantine. Others are not in the park at all, but they have been neighbors and have become so much a part of the park's ambiance that it is difficult to draw a line of demarcation. Among these are the Parks Administration Building on Clifton Avenue, the castlelike old Barringer High School, and the Sydenham House, Newark's oldest private residence. Also featured are an old cast-iron water fountain and the specially designed park bench with the letters "ECPC" intertwined in its arm rests. The bandstand, which hosted so many summer concerts, now lives only in memories.

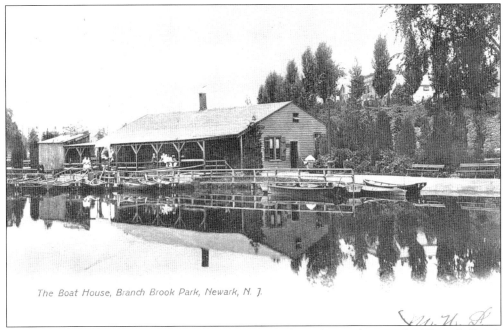

The Boat House, Branch Brook Park, Newark, N. J.

The above postcard shows the first boathouse erected on the southern end of Branch Brook Park Lake. It is quite rustic in design, especially compared to its successor, shown below on a 1910 postcard. The more elaborate second boathouse became a favorite destination for company outings and picnics, as well as a site for trout fishing and ice-skating in the winter. Boats were available for hire and were much in demand.

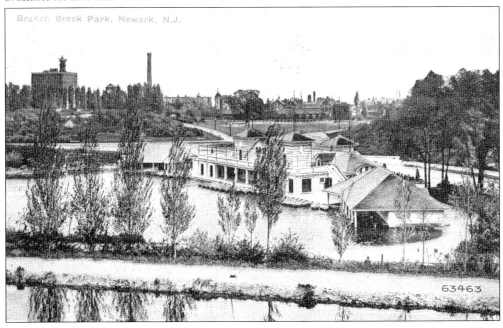

Branch Brook Park, Newark, N.J.

63463

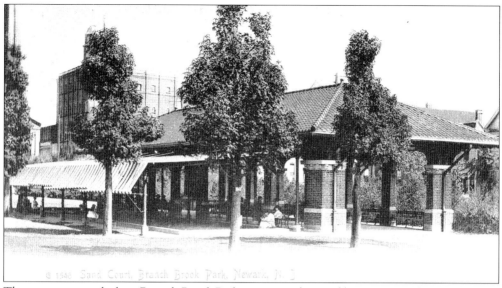

These two postcards show Branch Brook Park structures designed by Carrère and Hastings, both located in the Southern Division. Above is the Sand Court Shelter, the first building erected in the park. During the hot summer months, there was an awning that protected young children playing in the sandbox. Below is the Octagon Shelter on Meeker Mound. The Sand Court Shelter is still standing; the Octagon Shelter is in the process of being rebuilt according to the original design. Carrère and Hastings is best known for its design of the New York Public Library on Fifth Avenue.

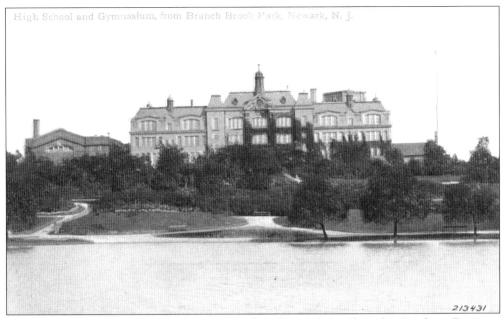

213431

A new high school was built on the eastern edge of Branch Brook Park's Southern Division, overlooking the Terrace Gardens. It was eventually renamed Barringer High School. The 1913 postcard above shows the gymnasium to the left of the school that was added to the school complex. Seen below is a 1905 view of the school from its main entrance showing the weather station located on its side lawn.

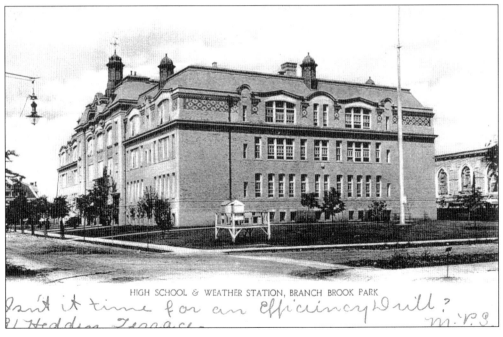

HIGH SCHOOL & WEATHER STATION, BRANCH BROOK PARK

Isn't it time for an efficiency Drill?
81 Hedden Terrace. M. V. S

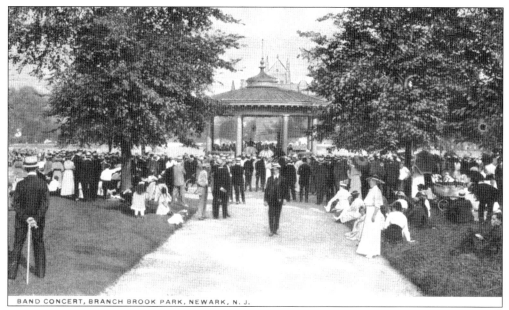

BAND CONCERT, BRANCH BROOK PARK, NEWARK, N. J.

The bandstand in the Southern Division was the site of well-attended concerts sponsored by the *Newark Daily Advertiser*. The above postcard view is taken from the rear of the bandstand, looking out over Branch Brook Park Lake. This may have even been a Fourth of July concert accompanied by fireworks. The 1901 Annual Report of the Essex County Park Commission reported "that as many as twenty thousand people have at one time assembled to hear the music."

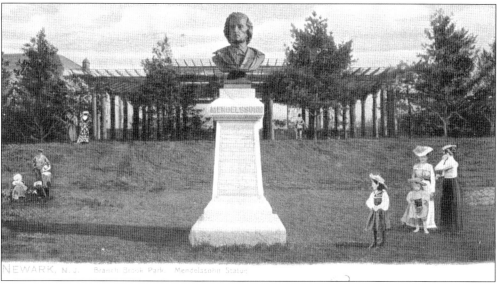

NEWARK, N. J. Branch Brook Park. Mendelssohn Statue

This 1907 postcard highlights a bust of the 19th-century composer Felix Mendelssohn. This was donated by the United Singing Societies of Newark in 1903. Here it is shown in front of the Terrace Garden arbor; other photographs show it at the base of the lawn leading down from Barringer High School. At some point the statue was removed and stored in a park maintenance shed, where it had been placed for safekeeping to prevent it from being vandalized. Occasionally it is placed on display in the entrance foyer of the Essex County Park Administration Building.

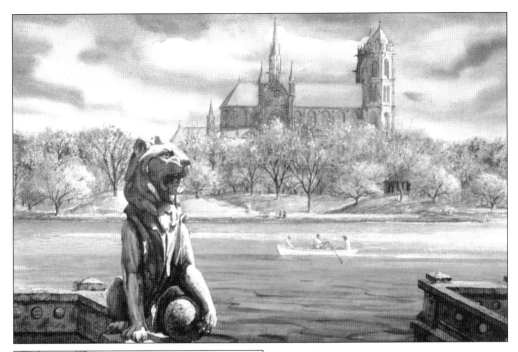

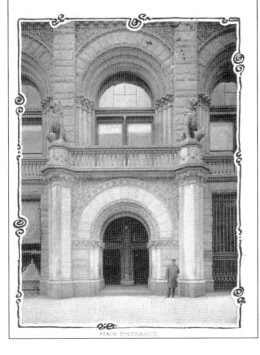

MAIN ENTRANCE.

On the occasion of Newark's 300th anniversary in 1966, the Prudential Insurance Company of America commissioned a series of watercolors of Newark scenes by Henry Gasser. This serene painting depicts one of the two lions that have graced the lake edge in Branch Brook Park since they were gifted in 1959 to Essex County by the Prudential Insurance Company of America. The lion statues were sculpted by Karl Bitter and originally stood above Prudential's main entrance from 1901 to 1956, as shown on the postcard on the left. Estimates have the weight of the statues at three tons each. (Above, photograph courtesy of the Prudential Insurance Company of America, Newark, NJ © 1966. All rights reserved. No further reproductions may be made without the express written consent of the Prudential Insurance Company of America.)

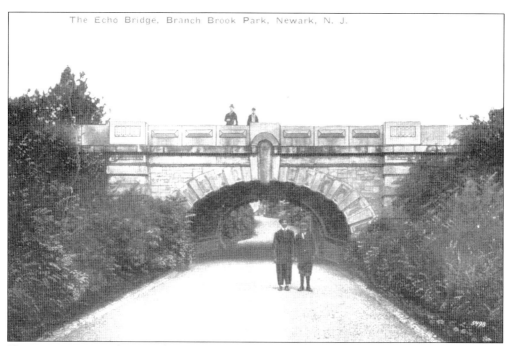

Here are two views showing the opposite sides of the same bridge in Branch Brook Park. The postcard above depicts park visitors strolling into the park, and the photograph below shows the reverse side. Note that the stonework design is different on the two sides of the bridge.

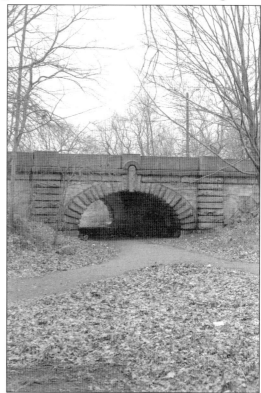

The eastern side of the bridge has a rustic theme, in keeping with the idea that when in the park, one is surrounded by nature. The western side has a more sophisticated design to signal that as one passes through the bridge from that direction, one is reentering the modern world.

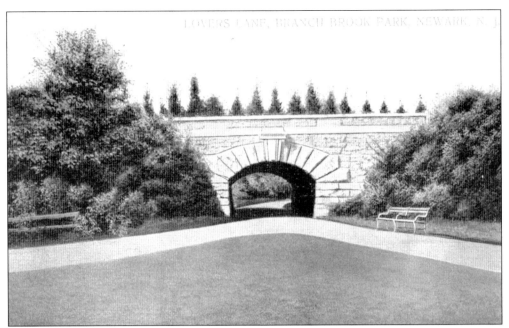

Another stone bridge is referred to as "Lovers Lane" on this 1909 postcard. These stone bridges were often referred to as "subways" because they went under the roadway. This design technique allowed park visitors to enjoy the tranquility of the park without interference from traffic on the roadway above.

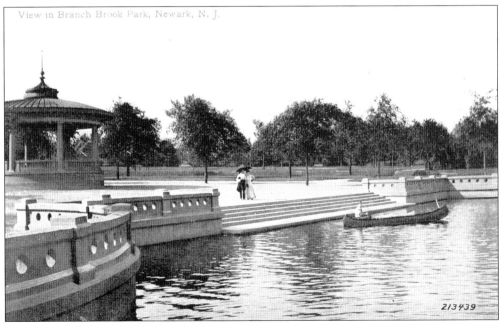

View in Branch Brook Park, Newark, N. J.

213439

Shown on a postcard dated 1911, this is the Concert Grove boat landing with the bandstand in the background on the left. Park visitors out for a day's rowing or paddling would often pull up here for a respite.

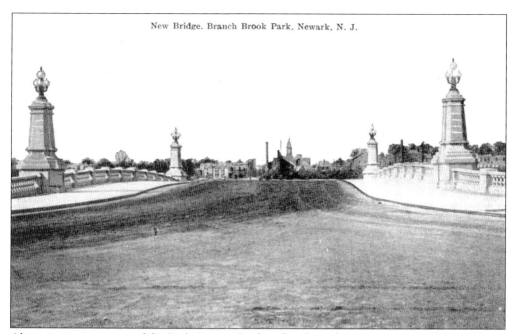

New Bridge. Branch Brook Park, Newark, N. J.

Above is a unique view of the Park Avenue Bridge, shot from the vantage point of the roadway. The postcard below displays how the park planting plan has filled in the landscape around the bridge so majestically.

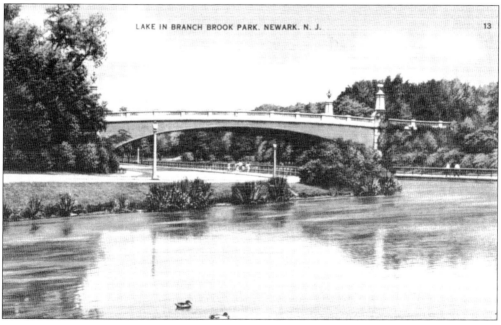

LAKE IN BRANCH BROOK PARK. NEWARK. N. J. 13

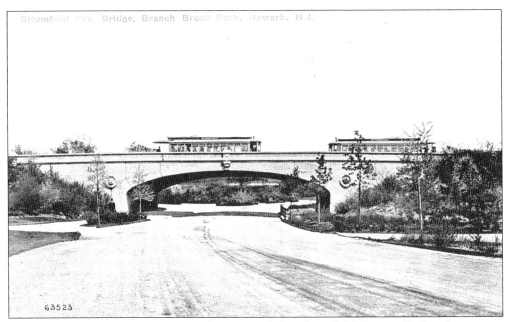

63523

The 1911 postcard above provides a clear view of the Bloomfield Avenue Bridge that crosses over Branch Brook Park. This picture must have been taken during rush hour, with two trolley cars carrying commuters to and from downtown Newark to its suburbs of Bloomfield, Montclair, and Verona.

Shown here is the former boathouse in the Middle Division that is currently used as a senior citizens activity center. When a portion of lake was filled in to accommodate parking, the building no longer served as a boathouse. In the foreground are bocce courts, which are well trafficked by enthusiasts of that sport. This building is adjacent to the Middle Division Ballfield Complex.

This imposing structure, another Carrère and Hastings design, was known simply as "the Shelter." It was located in the Southern Division near Parker Street and Fifth Avenue (now Park Avenue). This photograph is dated 1899, making this one of the first buildings erected in Branch Brook Park.

The Sydenham House was built around 1711 and is located on the Old Road to Bloomfield, near Heller Parkway and opposite the horseshoe pits in the Northern Division of Branch Brook Park. It is the second-oldest building in Newark and the oldest under private ownership. Built of sandstone and wood, the Sydenham House is listed on both the National and New Jersey Registers of Historic Places.

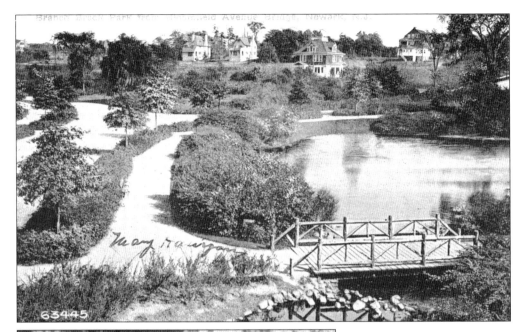

The 1911 postcard shown above provides an aerial view of Branch Brook Park Lake with the Rustic Bridge to Clark's Island in the foreground and the grand homes of Forest Hill in the background. The Rustic Bridge no longer stands, and there is no means of accessing Clark's Island. In the 1940s photograph at left, Helen (Maden) MacMunn posed proudly on the Rustic Bridge with her son, 1st Lt. George MacMunn, United States Air Force.

NO. 202--SCENE IN UPPER DIVISION--BRANCH BROOK PARK, NEWARK, N. J.
PUB. BY I. STERN, BROOKLYN. N.Y

These postcards show fine views of two of the stone bridges in the Northern Division of Branch Brook Park. The postcard above is dated 1908, and the one below is dated 1907. Both display the uniqueness of these bridges and the soothing tranquility of the surrounding scenery.

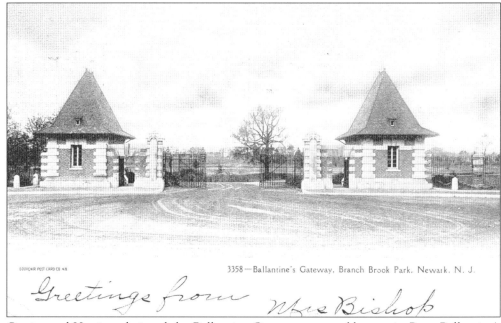

3358—Ballantine's Gateway, Branch Brook Park, Newark, N. J.

Greetings from *Mrs Bishop*

Carrère and Hastings designed the Ballantine Gateway to resemble ones in Peter Ballantine's home country of Scotland. The photograph shown on the above 1908 postcard was probably taken soon after construction of the gates, since the foreground shows a large open space. The postcard below presents a different scene, with the courtyard opposite the gateway now landscaped and sectioned off with bollards and a chain rope. Note the horse and carriage coming through the gates, which are located at the intersection of Lake Street and Ballantine Parkway.

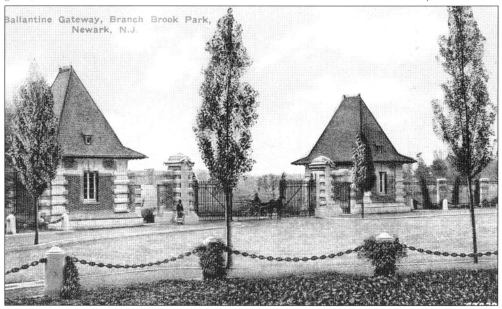

Ballantine Gateway, Branch Brook Park, Newark, N.J.

The Ballantine Gateway is a popular landmark in Branch Brook Park and attracts photographers and artists alike. Shown above is a watercolor by Edwin Harms, from the collection of the Paul A. McDonough Sr. family. This winter scene conveys the peace and tranquility that is the design concept in the Northern Division. The photograph to the right shows a close-up of one of the gatehouses and its wrought iron gate. This photograph was included with the documentation submitted when the park was nominated in 1979 to the National and New Jersey Registers of Historic Places.

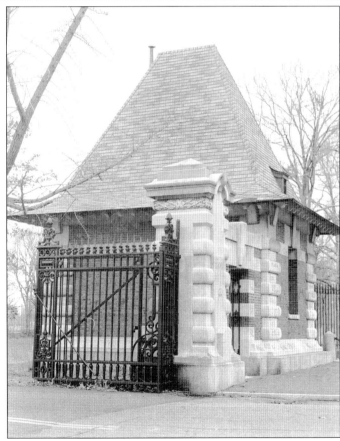

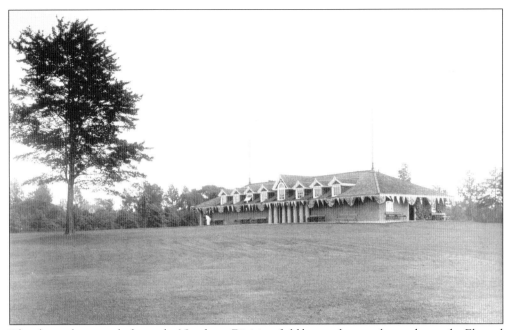

The above photograph shows the Northern Division field house that was located near the Elwood Avenue entrance to Branch Brook Park. This building is no longer standing, but this area is now the scene of free concerts in the park by the New Jersey Symphony Orchestra.

Although it has been replaced, the field house in the area of the Extension known as the "Four Diamonds" is shown in the photograph to the left. This was one of several prefabricated structures built by Sears, Roebuck and Company that were placed in the park. In its stead is a new visitors center built with an Oriental design, which serves as an appropriate backdrop to events held in conjunction with the Cherry Blossom Festival.

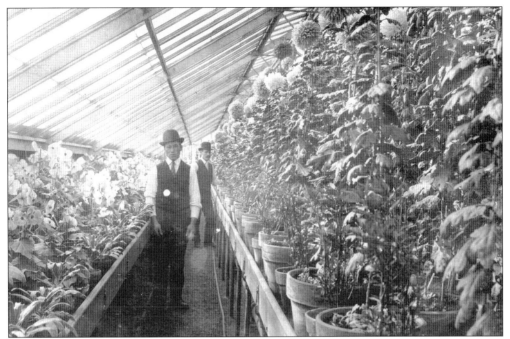

Staff gardeners are shown in the photograph above of the Branch Brook Park Greenhouse that used to stand in the Northern Division at Heller Parkway. It would appear that the gardeners are readying the plants for the annual Chrysanthemum Show, which used to take place in the park every fall.

This photograph shows another prefabricated structure built by Sears, Roebuck and Company. This is a maintenance shed located in the Extension at the intersection of Mill Street and Franklin Avenue.

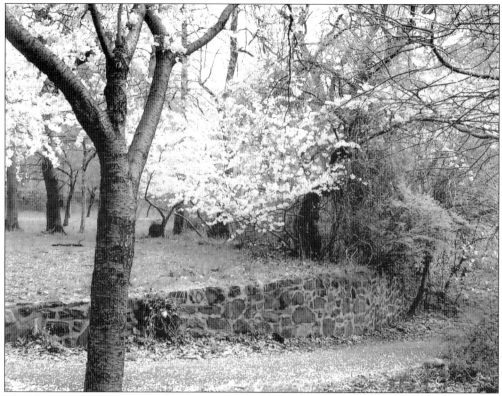

The photograph above gives a lovely view of the cherry blossom trees along the Second River and shows a stone wall erected by the Works Progress Administration (WPA) at the time the river was channelized during the creation of the Extension in Branch Brook Park. Shown below is a photograph from another stone wall along the Second River, identifying the wall as having been built by the WPA.

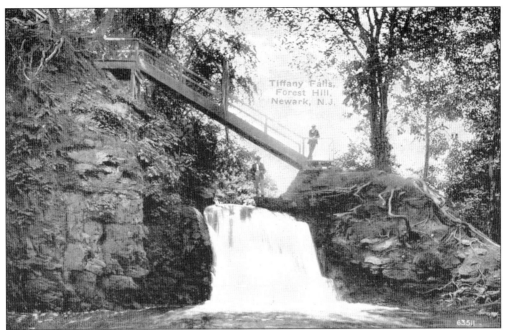

Tiffany and Company of New York City had a major manufacturing facility in Forest Hill, where most of the firm's silver products were produced. One of the major advantages of this location was the adjoining railroad line. Tiffany and Company owned land along the Second River, including the feature known as the Tiffany Falls shown on the above postcard. When the Essex County Parks Commission was acquiring land to expand Branch Brook Park, Tiffany and Company donated a portion of its land to be included in the park. The castlelike Tiffany and Company factory is shown on the c. 1905 postcard below. The plant closed in the 1980s and has since been converted into condominium apartments.

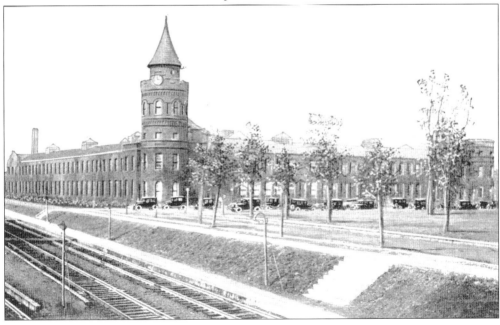

Structural elements in the park are more than just buildings and bridges. The photographs presented on these two pages were included in the nomination of the park to the National and New Jersey Registers of Historic Places to show important design features that people identify with Branch Brook Park. To the left is a pillar from one of the three concrete bridges spanning the Second River with a clearly Oriental flavor.

The photograph to the right shows a portion of the massive wrought iron gate connecting the twin structures of the Ballantine Gateway. This gate was constructed so that it could easily be pulled across, blocking the entrance to the park. In reality, no one recalls ever seeing the gates closed.

The park bench to the right was specially designed for use in Essex County's parks. The initials "ECPC" representing the Essex County Park Commission are clearly entwined in the cast-iron armrests.

A familiar scene in the 1950s and 1960s, this cast-iron drinking fountain to the left no longer exists in Branch Brook Park. Its artistic design and style evidenced the care that was taken in selecting even the most utilitarian adornments for the park.

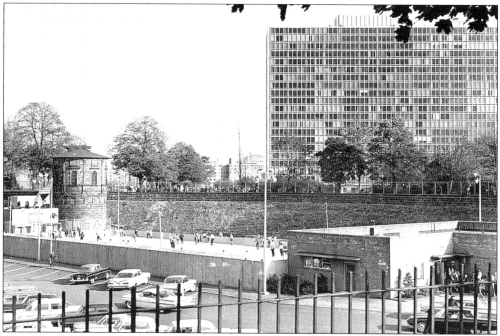

Looking over the wall of the old city reservoir in the above photograph, one sees the outdoor ice-skating rink, a favorite meeting place in the 1950s and 1960s. To the rear of the rink is the original brownstone tower for the reservoir. Looming above the horizon on the right is one of the Colonnade apartment buildings designed by an icon of modern architecture, Ludwig Mies van der Rohe.

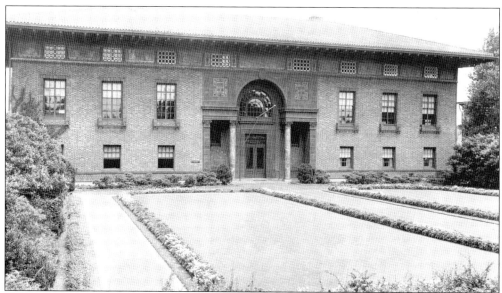

This stately administration building was built on parkland to house the offices of the Essex County Park Commission. Constructed from 1914 to 1916 according to the design of H. Van Buren Magonigle, architect, special features include the palladium window in the front and the murals painted by Edith M. Magonigle that appear above the arched entrance. This building has been placed on the National and New Jersey Registers of Historic Places.

Five

ENJOYING THE PARK

The credo of 1895 still holds: Parks are for People.
—Essex County Park Commission,
75th Anniversary Annual Report, 1969

"If you build it . . . people will come," says the young daughter to her father in *Field of Dreams*. As soon as Branch Brook Park was built, even before the first flowers bloomed, people started to come, first for ice-skating and then for lawn tennis, bocce, baseball, cricket, and as many other recreational activities as can be described.

The water has always been a special attraction whether canoeing on the lake, fishing for trout from a rowboat, or wandering along the shore taking pictures. Children and their parents flocked to the Sand Court Shelter or took to the wading pool. Schools scheduled their Field Day events, and the playgrounds were constant places of activity. Walking the family dog or promenading under the willows with parasol in hand, the park has provided a place for everyone to find their own special enjoyment. Horse-drawn carriages were a frequent sight, later replaced with the automobile taking the family on a leisurely drive. Whether one chooses to enjoy the park with hundreds of others during a concert at the bandstand, or participating in the Cherry Blossom Run as petals fluttered through the air, or sitting in the shade reading a book, the park provides one with the opportunity to do it all.

In the very early days, before the Extension became famous for the cherry blossom trees, members of the private Forest Hill Field Club took to the links for a round of golf. Today in the Middle Division, Essex County has built state-of-the-art baseball fields to provide youngsters with a chance to hit that base-clearing home run.

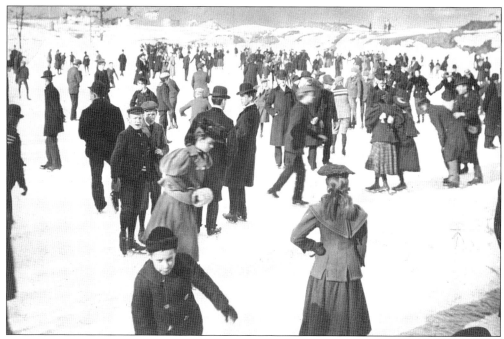

In the 1800s, ice-skating was a popular social activity. It provided exercise and fresh air, was the wintertime equivalent of promenading, and was an acceptable courting ritual. The photograph above was taken in the early 1880s and shows ice-skaters on the old Blue Jay Swamp, which land became part of Branch Brook Park. The photograph below is dated January 1, 1910, and shows ice-skaters on the frozen lake by the boathouse.

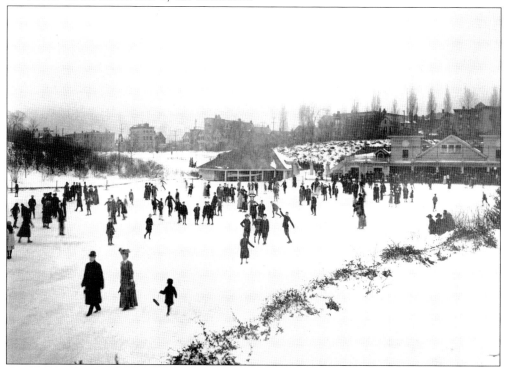

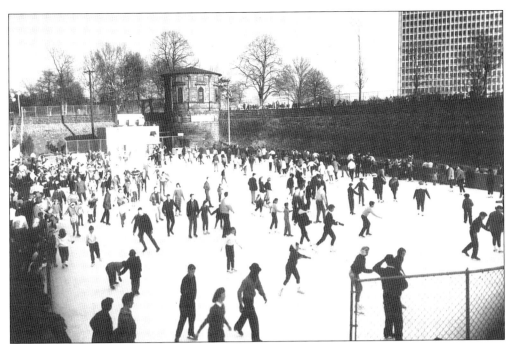

After the city reservoir was drained, it would be flooded for ice-skating in the cold weather. In the photograph above, the water tower from the reservoir is still standing. The 1958 photograph below shows nighttime ice-skating in the open-air rink. In the 1970s, the ice-skating rink was demolished and later replaced with an indoor roller-skating rink.

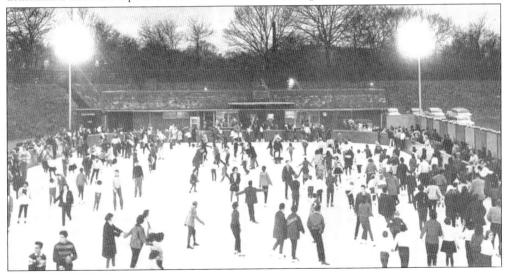

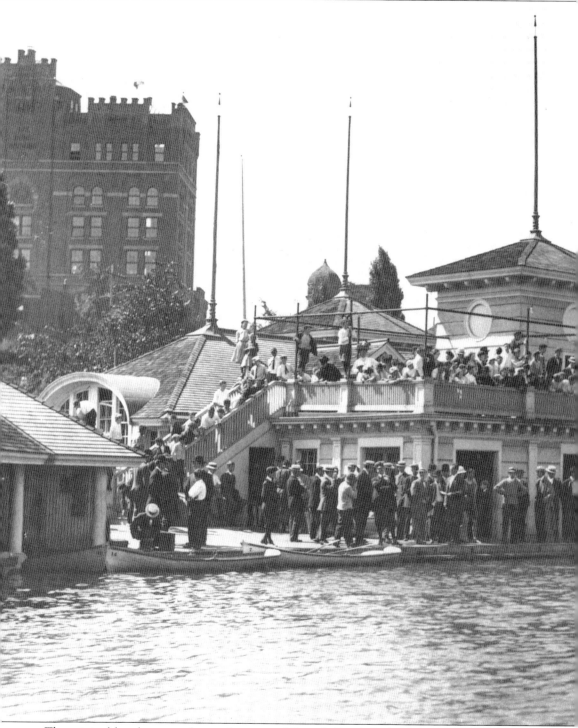

The original boathouse at the southern tip of Branch Brook Park was replaced by the larger structure pictured above. The original was a more rustic design, but the new boathouse was much more elaborate. This photograph is titled "Home Brewing, c. 1910" and probably depicts a

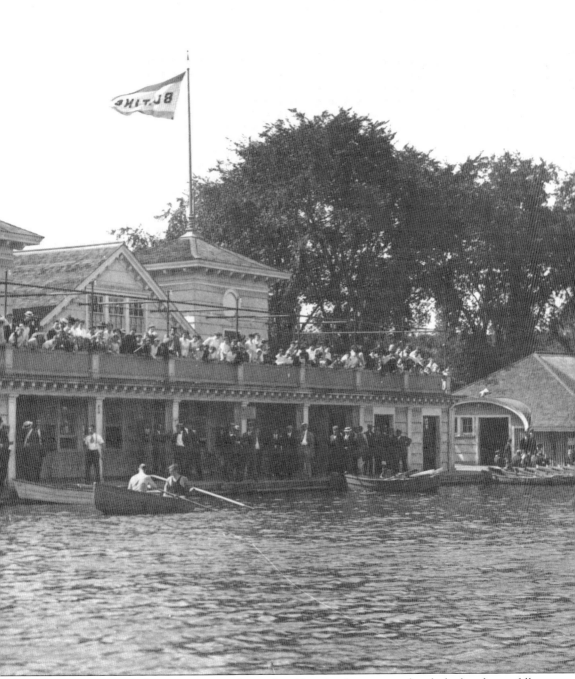

company outing. As leisure activities changed and boating became outdated, the boathouse fell into disuse. Another factor contributing to its decline was climate changes that prevented the lake from freezing, so people no longer came to the boathouse for ice-skating.

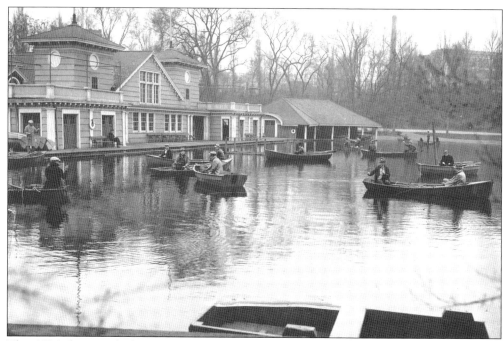

This 1936 photograph shows trout fishermen in front of the boathouse at the southern tip of Branch Brook Park. The lake is still stocked with fish, but today most people fish from the bridges and promenades.

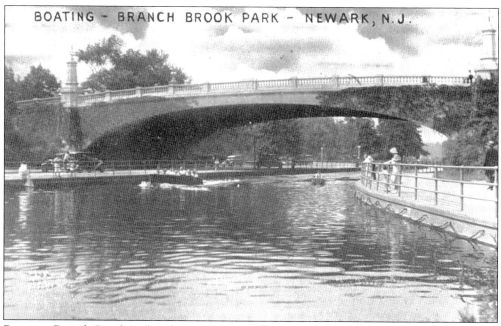

BOATING - BRANCH BROOK PARK - NEWARK, N.J.

Boats on Branch Brook Park Lake were powered by motor in this 1930s postcard showing the promenade and lake under the Park Avenue Bridge.

This postcard shows police boats and officers on duty at the lake in Branch Brook Park. They are stationed on the west shore just north of the boathouse. Note the bicycle—they are ready for anything.

Essex County park policeman Gilbert Strong is shown piloting a new boat on Branch Brook Park Lake in this 1937 photograph.

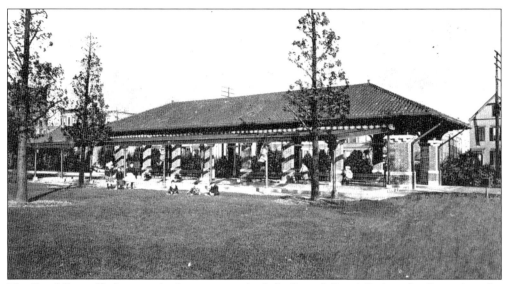

The Sand Court Shelter was the first structure built for Branch Brook Park and still stands at the southern end of the park, at the intersection of Clifton Avenue and Route 280. It was a favorite play spot for children and was surrounded by promenades and formal gardens and terraces.

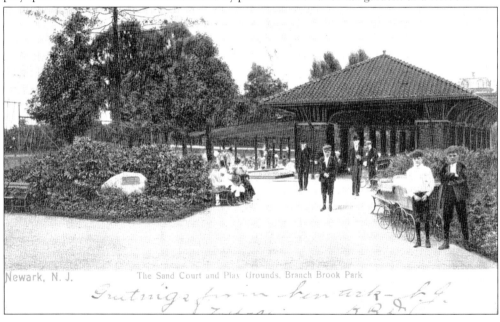

Newark, N. J. The Sand Court and Play Grounds, Branch Brook Park

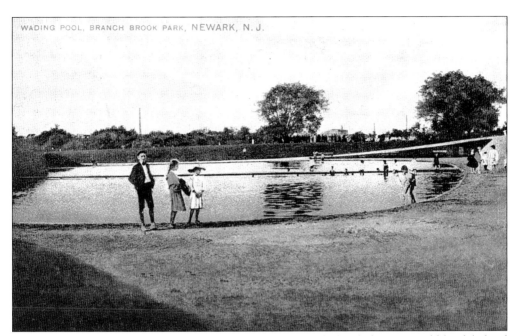

WADING POOL, BRANCH BROOK PARK, NEWARK, N. J.

Children living in city tenements or even middle-class multifamily homes would be delighted to splash around in the wading pool in Branch Brook Park, shown above in a 1907 postcard. This might be their only opportunity to cool off in the hot summer weather. The children's playground, below, was the scene of both organized activities and spontaneous games.

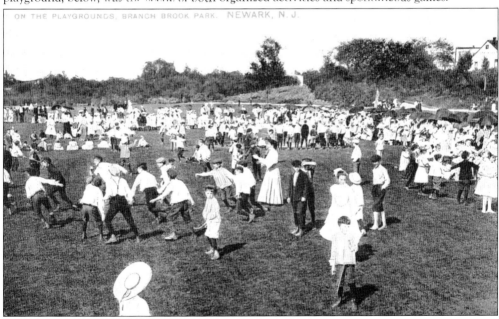

ON THE PLAYGROUNDS, BRANCH BROOK PARK. NEWARK, N. J.

Families visited Branch Brook Park in all seasons. The photograph above shows Filomina DiGiacomo and her son-in-law Jerry G. Fernicola with their dog Buster bundled up on a blustery day in the mid-1930s.

Alice MacMunn posed on the promenade near the Park Avenue Bridge. MacMunn married Newark firefighter Edmund J. Burke, and they raised their four sons in the Forest Hill section of North Newark.

This elegant couple makes the quintessential promenading portrait in a scene set in the Willows at Branch Brook Park. This photograph and many others of the same era contained in this book were taken by William F. Cone, the premier professional photographer of his day in Newark.

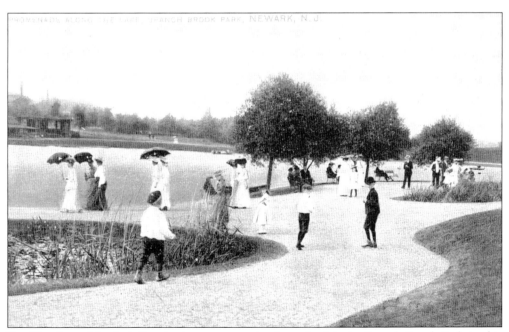

Families dressed in their Sunday best promenade along the lake in Branch Brook Park in this early postcard.

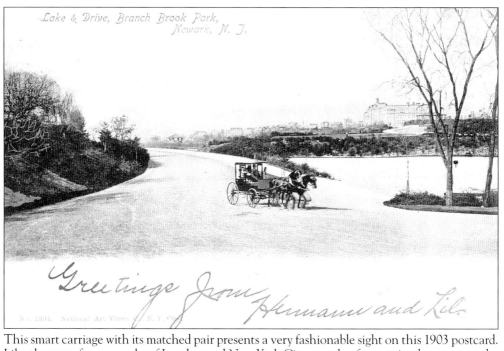

Lake & Drive, Branch Brook Park, Newark, N. J.

Greetings from Hermann and Lil.

No. 1334. National Art Views Co., N. Y. City

This smart carriage with its matched pair presents a very fashionable sight on this 1903 postcard. Like the more famous parks of London and New York City, people of a certain class went to the park to see and be seen, whether promenading on foot or riding in their carriages.

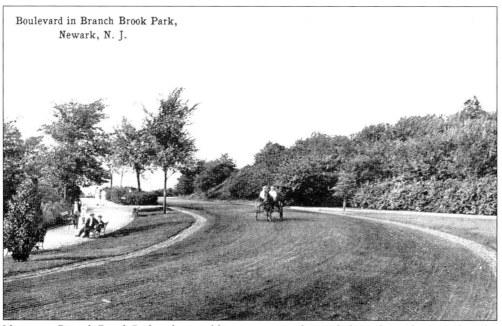

Boulevard in Branch Brook Park, Newark, N. J.

Visitors to Branch Brook Park today would not recognize the roads from these photographs. The original wide boulevards offered the respite of open space as compared to narrow, crowded city streets. Here a pony trap provides a leisurely ride along the boulevard in Branch Brook Park.

86

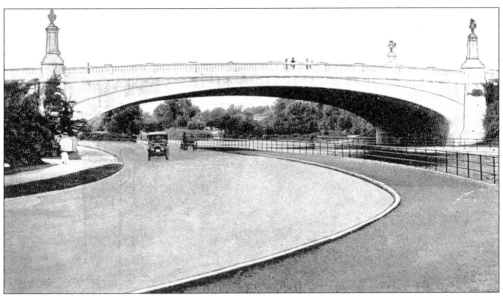

Automobiles eventually made their way into the park. Here vintage cars progress along the boulevard under the Park Avenue Bridge.

The Essex County Park Commission,

800 Broad Street.

Newark, N. J., Dec 26 190,

PERMISSION IS HEREBY GRANTED

Mr. *George Paddock*

to run an Automobile in Branch Brook and Orange Parks, subject

to regulations printed on this permit.

a. Church
Secretary.

The advent of automobile traffic may have presented a quandary to the Essex County Park Commission. After all, parks were supposed to provide quiet, reflective oases in the middle of the bustling city. But automobiles were becoming a fact of life, and if horse carriages were allowed in the park, then why not horseless carriages? Here is a copy of a permit issued by the county to allow George Paddock to operate an automobile in the park.

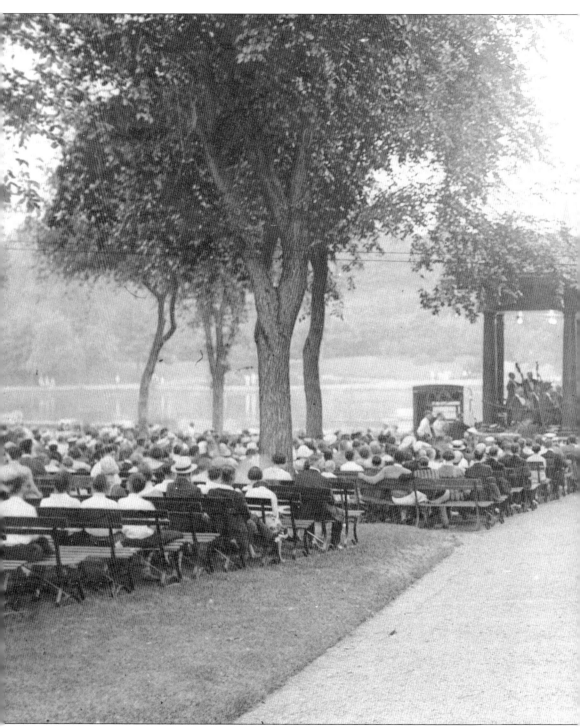

This concert drew quite a crowd to the bandstand in Branch Brook Park. The Newark Philharmonic Band was photographed in concert at 8:30 p.m. on July 19, 1926, and the photograph ran on page one of the *Newark Sunday Call* on July 25, 1926. The scene is photographed from the rear of the bandstand, looking east over the lake. These concerts were regular events.

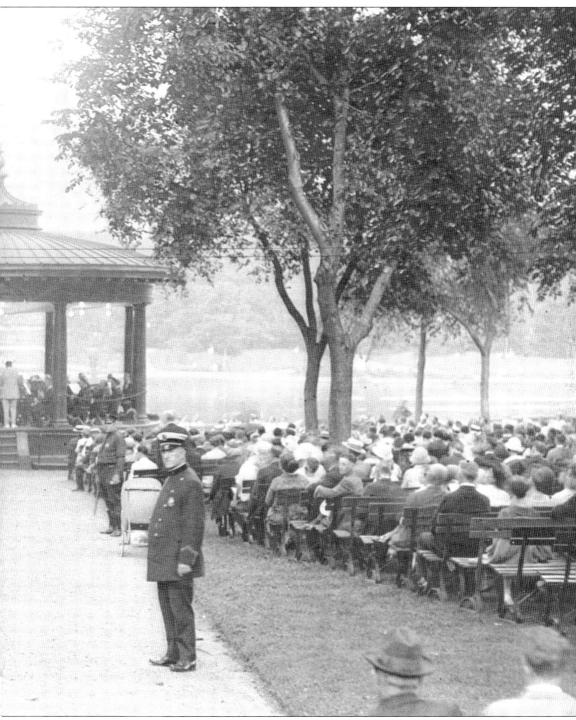

Today the New Jersey Symphony Orchestra performs once a year in the Northern Division near the Elwood Avenue entrance to the park, accompanied by a fireworks display. A few concerts featuring popular music are also held each year on the site of the former bandstand.

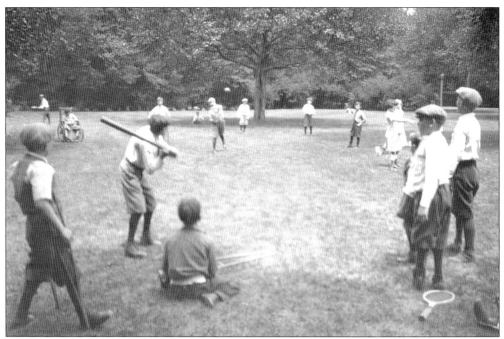

"Crippled Children on Playground in Branch Brook Park" is the title of this photograph taken in June 1927. Crutches, canes, and a wheelchair are all seen being used by some of the children. This may have been an outing from the old Newark Crippled Children's Hospital on Park Avenue, just a few blocks from the park.

Boys of all ages are engaged in various activities in the playground at Branch Brook Park. A large game of ring-around-the-rosie is in progress, and the swings and other playground equipment are fully occupied.

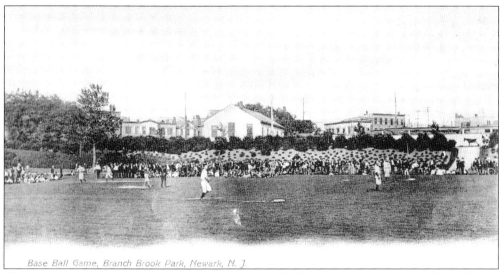

This postcard view shows a large, well-organized baseball game in Branch Brook Park. Notice the huge crowd of spectators.

Joseph N. DiVincenzo Jr. grew up in the shadow of Branch Brook Park and played shortstop on Barringer High School's baseball team. Elected Essex County executive in 2002, he is committed to the Essex County Park System including Branch Brook Park. In speaking about the park, he says, "Branch Brook Park was our resort. We had no car, so for weekends and vacations, sports and family parties, we headed to Branch Brook Park."

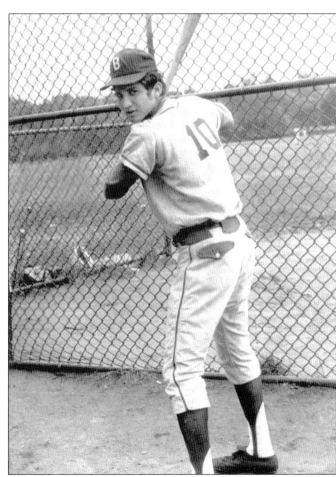

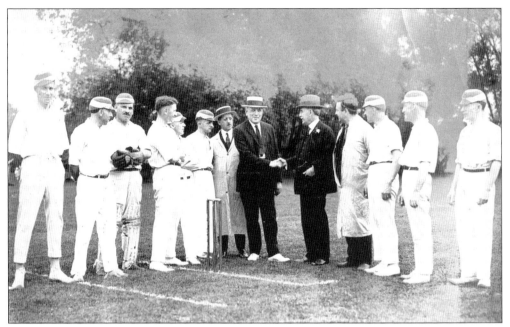

Cricket has been a popular game in Branch Brook Park since the early 1900s and is still played there. Enter the park at Elwood Avenue and walk across the lawn to watch a game, or drive south into the park from Heller Parkway and park on the western roadway. At one time, there were dozens of cricket teams active in this area of New Jersey, with championship games hotly contested at the end of each season.

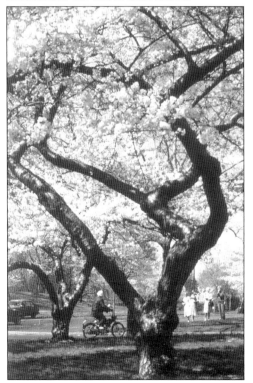

Not interested in team sports? Anyone can ride their bicycle leisurely along the many miles of trails through the park. Bicycle road races are also held there several times a year, including the Cherry Blossom Bicycle Tour event.

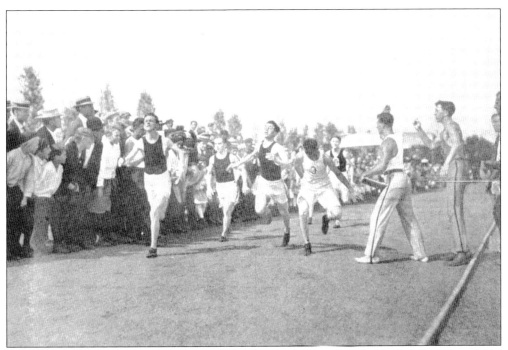

Track and field competitions were also held on the running track in the park. This was probably a high school meet in the early 1900s.

Held annually during the Cherry Blossom Festival, the Cherry Blossom Run attracts competitors from throughout the tristate area and beyond. This 1977 photograph shows everyone joining in the fun, but the event has since become more organized. The popular 10-kilometer race is part of the USA Track and Field of New Jersey Grand Prix Series, and there are also a Children's Fun Run and a Race for the Disabled.

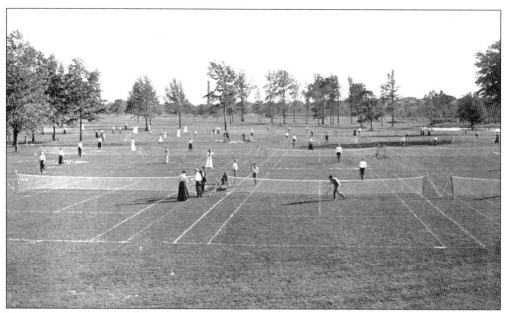

Lawn tennis was a popular sport for both men and women. This 1901 photograph shows the grass courts in the Northern Division of Branch Brook Park. The game must have been more leisurely in those days, given the strictures of women's clothing.

In the early 1930s, Helen (DiGiacomo) Fernicola posed on the grass tennis courts in Branch Brook Park.

In 1927, new tennis courts were built with a clay surface. They were located between Heller Parkway and Grafton Avenue, on land that was formerly the apple orchard of the Isaiah Crane farm. The photomontage to the right shows construction of the new courts and the finished product. The photograph below shows the tennis field house built at the same time. These tennis courts still attract players, although they have been resurfaced and there are now 16 asphalt courts and 4 with a substitute clay surface. The original tennis house was manufactured by Sears, Roebuck and Company, but it has since been replaced.

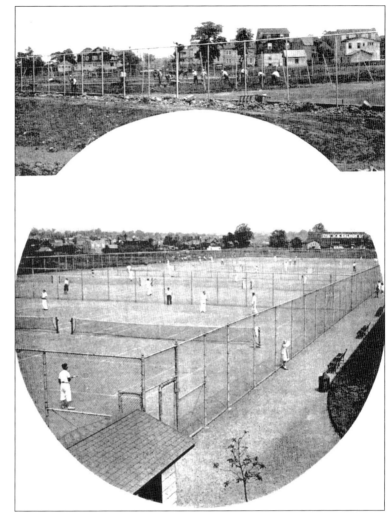

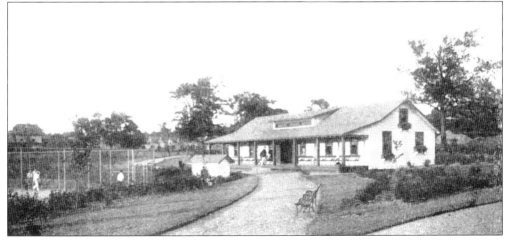

"This is the ribbon, isn't it, not the net?"

In her column titled "Court Manners" in the October 31, 1982, *Sunday Star-Ledger*, Kay Kato documented the dedication of the refurbished Branch Brook Park tennis complex, which has been named for tennis great Althea Gibson, who was in attendance. (From *Park Art with Pad & Pencil in the Parks for 31 Years* by Kay Kato, 1999. Used with permission of the Donning Company Publishers.)

There is a small playground next to the Branch Brook Park tennis courts that would occupy children or younger siblings while one played tennis. Pictured here playing in the sand is Holli Giarraputo (now Francis), the niece of Kathleen Galop.

This photograph from around 1900 shows William Ward Crane and two unidentified women preparing a grass tennis court for play. William was a direct descendant of Jasper Crane, one of the founders of the City of Newark.

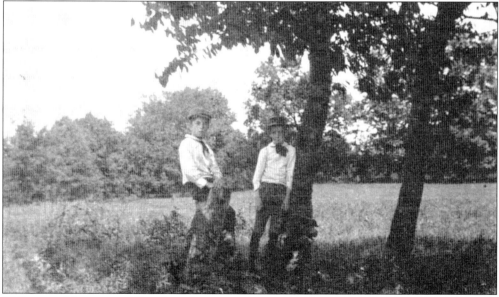

William and his cousin Theodore Crane are shown on the golf links of the Forest Hill Field Club, which backed onto the Crane family farm. This photograph is dated July 31, 1897.

The Forest Hill Field Club was a private membership club located at 810 DeGraw Avenue that provided facilities for baseball, tennis, and golf. When the club outgrew its Newark property, it relocated to Bloomfield in the 1920s.

The Forest Hill Field Club originally had a 9-hole golf course, but later expanded it to 18 holes. This postcard shows an aerial view of the Forest Hill Golf Links in 1906.

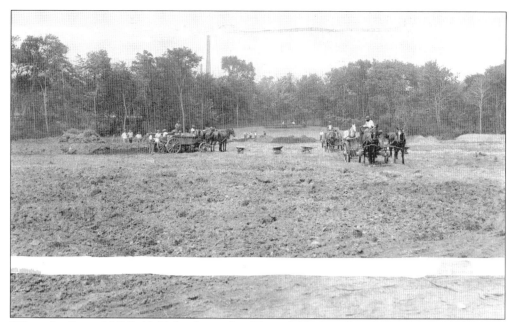

When the Forest Hill Field Club relocated to Bloomfield, its golf course was acquired by Essex County and expanded to include land in Belleville formerly owned by Harmon W. Hendricks. The new golf course was renamed Hendricks Field and opened in 1927 as Branch Brook Park Extension No. 2. The above photograph shows construction of the new golf course in the vicinity of the fifth green.

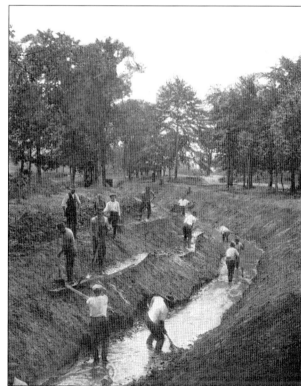

This 1927 photograph shows workers draining the lowland for the construction of Hendricks Field.

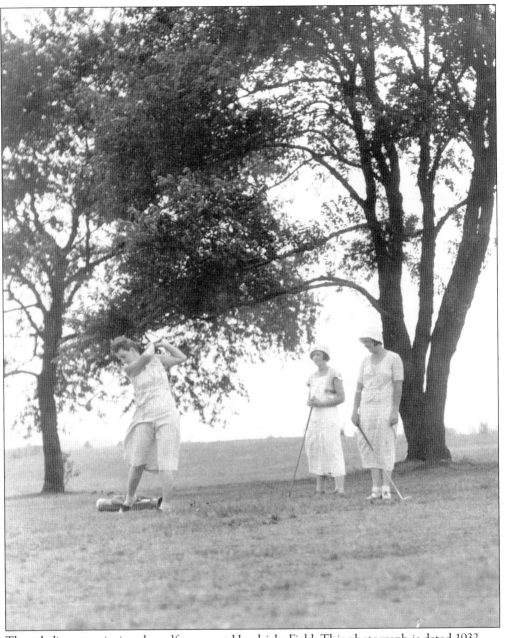

These ladies are enjoying the golf course at Hendricks Field. This photograph is dated 1932.

Six

WINTER SCENES

In Winter we can see the Park right through to its bones, and they are strong.
—Kathleen P. Galop and Catharine Longendyck,
April 2007

Long before anyone came to the park to see the flowers and the newly planted trees, they were ice-skating on what was known as Blue Jay Swamp. Once the carriage roads were passable, horse-drawn sleighs carried riders bundled under blankets and singing "Jingle Bells." It was an idyllic scene in the 1890s, and it continues to be just as idyllic today.

The structural beauty of the park and the curves of its landscape can best be seen in winter when snow covers the ground and stillness fills the air. One can feel the quiet as vistas from under arched bridges and along the frozen brook continue forever. Somehow the peacefulness in the park does not seem to exist outside its boundaries where the busyness of life takes over. In many ways, the park serves as a place of quiet reflection more so in winter than in any other season.

Quiet walks are more frequent. The handsomely built environment of the park rises out of the earth and commands attention. A park bench covered in snow is a photographer's delight. Silhouettes of the trees, so stark against a gray sky, offer a sense of strength and majesty. Evergreens dressed in white take spectators down a path and into a trellis that in the spring will be filled with fragrant wisteria.

Only in winter are the "bones" of the park really visible. They are strong and they will endure.

Under a Branch Brook Arch, Newark, N. J. 688

A tranquil, snow-covered scene is viewed from under the arch of a stone bridge in the Southern Division of Branch Brook Park. This 1906 postcard captures perfectly the peace of winter in the park.

Winter Scene in Branch Brook Park. Newark, N. J.

1304.

The scene of a horse-drawn sleigh in Branch Brook Park in a snow-covered landscape could be right out of a Currier and Ives print.

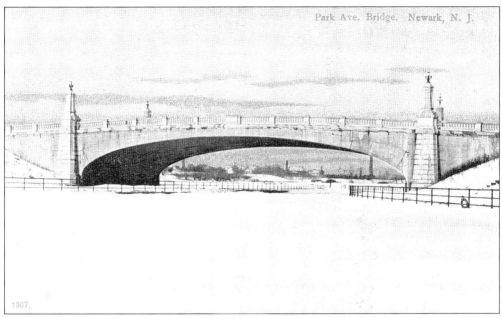

Branch Brook Park Lake in the foreground of the Park Avenue Bridge is frozen and snow-covered.

Ice-skaters take advantage of the frozen lake down by the boathouse in the Southern Division.

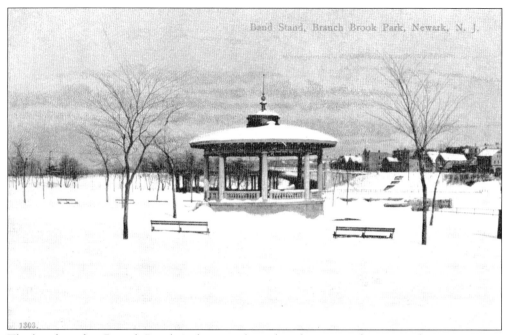

The bandstand in Branch Brook Park is snowbound in this postcard scene, with snow rising to the level of the seats of nearby park benches.

Clark's Island may appear desolate with its lush foliage covered in snow, but the Rustic Bridge is dressed for the season with a soft coating of white.

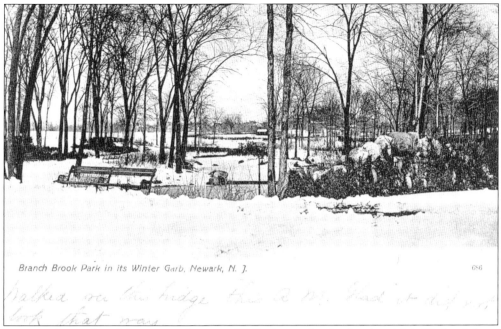

Branch Brook Park in its Winter Garb, Newark, N. J. 686

Walked over the bridge this A.M. Glad it did not look that way

In 1908, the sender of this postcard wrote, "Walked over this bridge this A.M. Glad it did not look that way." She was obviously not a fan of cold and snow, but nothing can detract from the beauty of this stone bridge.

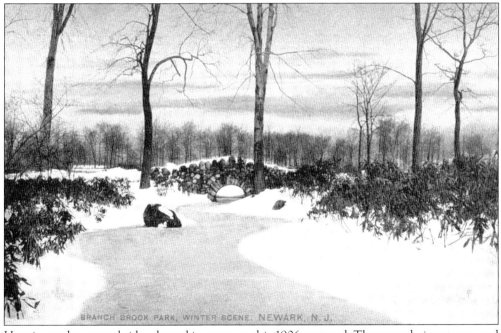

BRANCH BROOK PARK, WINTER SCENE. NEWARK, N. J.

Here is another stone bridge draped in snow on this 1906 postcard. The meandering stream and pillow-soft banks offset the stark outlines of the winter-stripped trees.

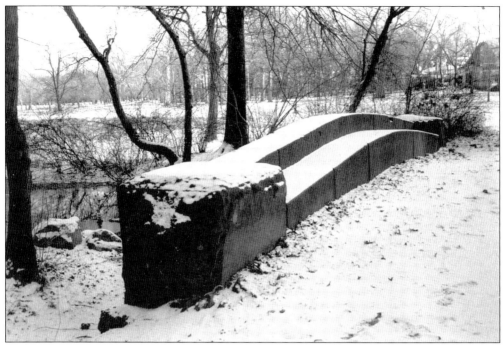

A frosting of snow covers the bench bridge in the Northern Division. This plainest of the Olmsted stone bridges was a perfect resting spot during a walk through the park and also was just right for lining up the children for a family photograph.

Even in winter, the cherry blossom trees stand out in the scenery of Branch Brook Park. Their shiny bark glows in the snowy landscape, and ice clings to their flowing branches.

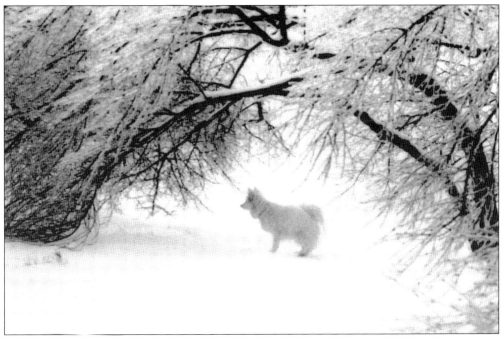

A snowy white dog romps through the snowy white landscape of Branch Brook Park, chasing snowflakes in and out of wintry hiding places. Sukki, an American Spitz, revels in a habitat natural to her breed.

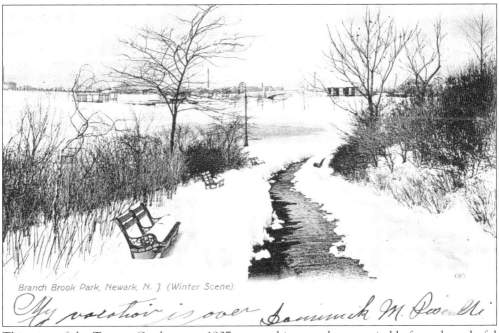

Branch Brook Park, Newark, N. J. (Winter Scene).

My vacation is over Dominick M. Pavelli

This view of the Terrace Garden on a 1907 postcard is scarcely recognizable from the colorful flower beds seen in the spring and summer.

The promenade leading up to the wisteria bower is buried under a blanket of white, with snow covering the park benches. The majestic trees stand as sentinels, waiting patiently for the park's rebirth in the spring.

Seven

THE CHERRY
BLOSSOM DISPLAY

The varied topography of broad greenswards, forest, lowland areas, bluffs, and riverbanks within
Branch Brook Park is reminiscent of the Japanese countryside.
—Rhodeside and Harwell,
Memorandum to the Branch Brook Park Alliance, April 2007

Branch Brook Park's original 2,000 flowering cherry blossom trees in 28 varieties were a gift to the park in 1927 from Caroline Bamberger Fuld. The timing of this donation was most propitious as it coincided with the enlargement of the park northward along the ravine of the Second River. Planting of the trees took place over a five-year period from 1928 through 1933, following a detailed planting plan designed by the Olmsted Brothers to showcase the flowering trees against a background of evergreens amid splashes of yellow forsythia. The delicate shades of the pink and white cherry blossoms in this specially created naturalistic landscape present a breathtaking palate of colors never to be forgotten.

The Yoshino, which is a single-blossom variety, starts blooming in late March or early April, followed by a succession of single and double blossoms of Higan, Subhirtella, Autumnalis, Sargent's Shirotae, Fijiyama, Gyoiko, Fungenzo, and the most popular double pink Kwanzan. The blooming period lasts for two to three weeks and returns pretty much on schedule every year. Very few of the trees from the original donation remain in the park as the life span of cherry blossom trees usually does not exceed 50 years. Essex County and the Branch Brook Park Alliance have pledged to plant thousands of additional trees to ensure that this collection will continue to bring spring to visitors for generations to come. Funding for this restoration of the cherry tree grove will come from private donations and the Essex County Recreation and Open Space Trust Fund.

Inspired by the cherry blossom trees in Washington, D.C., the Fuld Cherry Tree Collection in Branch Brook Park draws thousands of visitors from near and far. This display has become an important heritage tourist destination, affording everyone the opportunity to stroll and enjoy an experience that had once been a privilege reserved to the emperor of Japan. Residents of the area have particularly fond memories of annual visits to the park to take family photographs amid this springtime beauty. This chapter features photographs from the pages of family albums that the owners have graciously allowed to be shown.

Cherry blossom time in Branch Brook Park is a photographer's delight. Whether using a clumsy old 35 millimeter or the latest digital camera or a cell phone, the result is always the same. Scenes of profuse blossoms and gnarled tree branches will result in a perfect picture every time.

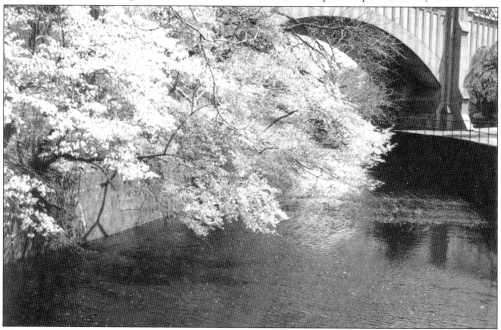

This appears to be one of the oldest trees in the park, gracefully arching over the Second River in the vicinity of the concrete railroad bridge. "Petals on the Water" might be an appropriate title for this photograph.

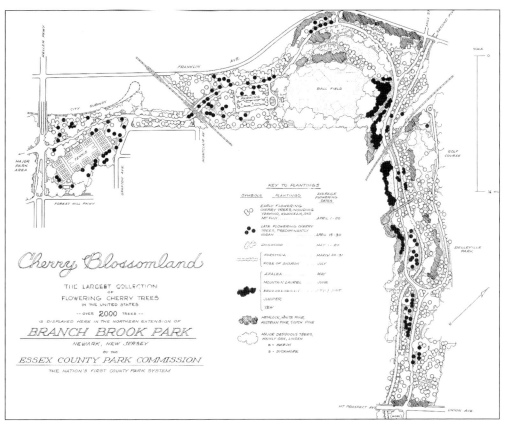

The map contains the following text:

Cherry Blossomland

THE LARGEST COLLECTION
OF
FLOWERING CHERRY TREES
IN THE UNITED STATES
-- OVER **2000** TREES --
IS DISPLAYED HERE IN THE NORTHERN EXTENSION OF

BRANCH BROOK PARK

NEWARK, NEW JERSEY
BY THE
ESSEX COUNTY PARK COMMISSION
THE NATION'S FIRST COUNTY PARK SYSTEM

KEY TO PLANTINGS

SYMBOLS	PLANTINGS	AVERAGE FLOWERING DATES
	EARLY FLOWERING CHERRY TREES, INCLUDING YOSHINO, KWANZAN, AND MT. FUJI	APRIL 1-20
	LATE FLOWERING CHERRY TREES, PREDOMINANTLY HIGAN	APRIL 15-30
	DOGWOOD	MAY 1-20
	FORSYTHIA	MARCH 20-31
	ROSE OF SHARON	JULY
	AZALEA	MAY
	MOUNTAIN LAUREL	JUNE
	RHODODENDRON	LATE MAY-JUNE
	JUNIPER	
	YEW	
	HEMLOCK, WHITE PINE, AUSTRIAN PINE, SCOTCH PINE	
	MAJOR DECIDUOUS TREES, MAINLY OAK, LINDEN B = BEECH S = SYCAMORE	

In 1976, the Essex County Park Commission distributed this map of Cherry Blossomland. It lists the many varieties of cherry blossom trees and their location throughout the Extension. It also claimed at that time that Branch Brook Park had "the largest collection of flowering cherry trees in the United States."

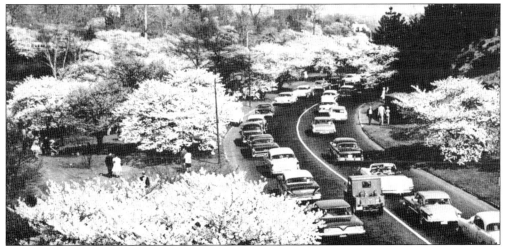

A familiar scene during cherry blossom time is the traffic slowly winding its way through Branch Brook Park. On occasion the roadway is converted to one-way traffic in both lanes to accommodate the thousands of visitors that come each year, including tour buses.

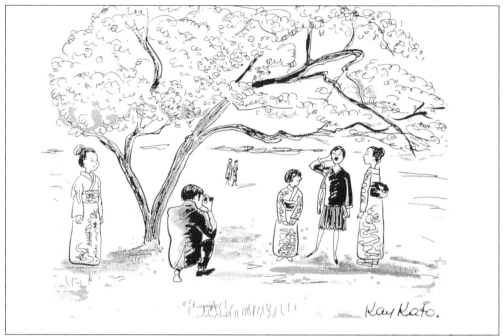

Visitors of Japanese ancestry in beautifully flowing kimonos are frequently seen among the flowering trees. Here they are captured by Kay Kato for her column "In the Pink," which appeared in the May 4, 1980, *Sunday Star-Ledger*. (From *Park Art with Pad and Pencil in the Parks for 31 Years* by Kay Kato, 1999. Used with permission of Donning Company Publishers.)

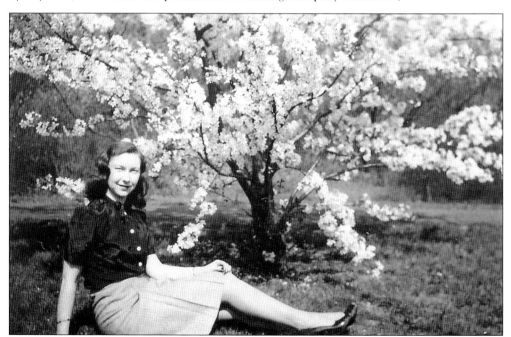

Dorothy (Galop) Hull of Summer Avenue visits Branch Brook Park on Easter Sunday 1945. The eldest of the eight children of Agnes Lee and Stephen Peter Galop, she was the aunt of coauthor Kathleen P. Galop.

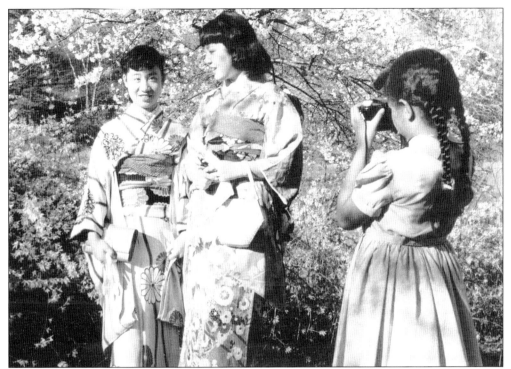

The Essex County Parks System Historic Documents Library contains this charming photograph of a young girl with camera in hand taking pictures of her family.

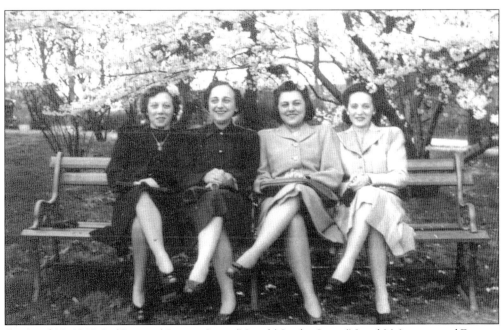

On April 12, 1942, Jo (Soriano) Lauria, Lena (Nittoli) Lecky, Irma (Nittoli) Morgese, and Frances (Soriano) Fraver posed in their springtime finery for their annual Easter season photograph amid the cherry blossoms in Branch Brook Park.

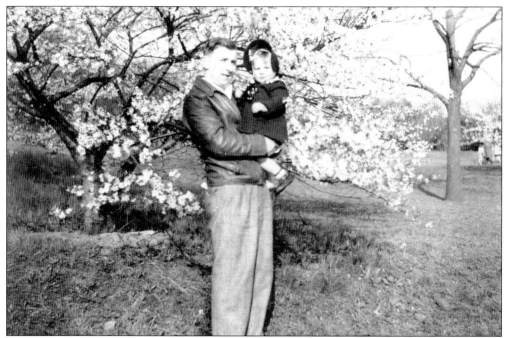

John F. Galop introduces his one-year-old daughter Kathleen to Branch Brook Park's cherry blossoms in 1948. Galop was born and raised in Newark and served for 37 years on the Newark Fire Department. He was also a veteran of World War II, participating in the D-Day invasion on the Normandy beaches and the Battle of the Bulge.

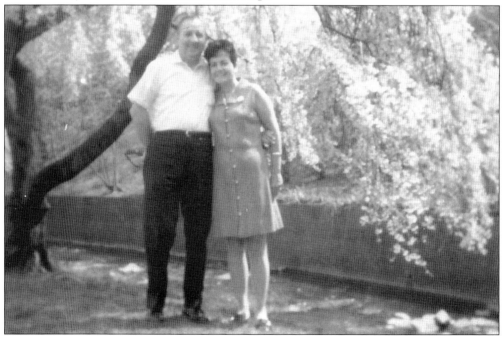

Under the branches of this beautiful weeping cherry are John F. and Helen M. (Koch) Galop, parents of coauthor Kathleen P. Galop. This photograph was most likely taken in the early 1970s.

The photograph to the right shows three generations of the Longendyck family of Newark. On Easter Sunday in April 1946, Alice (Werner) Longendyck, her daughter Mary (Longendyck) Nathanson, and her mother-in-law, Catherine (Doerr) Longendyck, posed under a flowering cherry blossom tree in Branch Brook Park.

On Easter Sunday 1952, coauthor Catharine Longendyck enjoyed the cherry blossoms with her brothers Robert M. Longendyck and Gerard J. Longendyck.

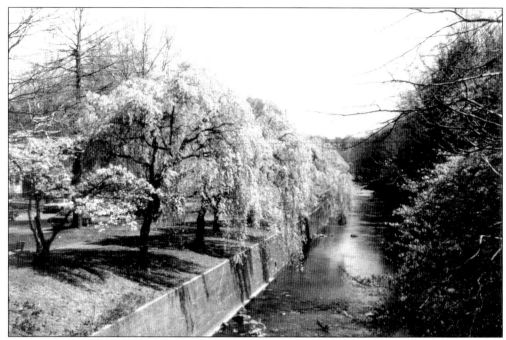

Scenes of the cherry blossoms in full bloom, like those shown in these two photographs, only begin to capture the full expanse of the beauty of the cherry blossom display designed to reflect the tranquility of the Japanese countryside.

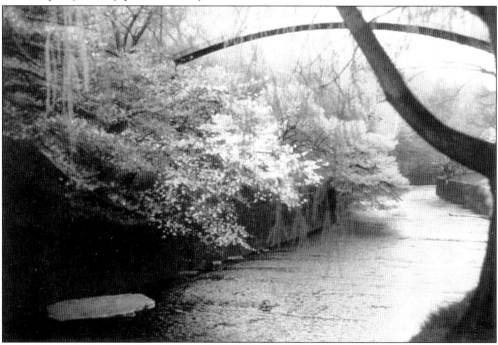

Eight

Renewal and a Vision for the Future

Its Cherry Blossom trees, beautiful landscapes and serene settings make Branch Brook Park a natural treasure and urban oasis within our busy county . . . recent improvements have renewed people's interest and given the public a greater feeling of ownership of its historic features.
—Essex County Executive Joseph N. DiVincenzo Jr.
April 2007

Determination and advocacy by the park's constituents since 1975 have set the course for the future of Branch Brook Park. Determined to focus attention on one of the city's most positive attributes and overcome the pervasive negativity after the riots, Gary Brian Liss, an environmental engineer, and Kathleen P. Galop, a corporate attorney, founded The Newark Cherry Blossom Festival in 1975. Response to this concept was phenomenal, and a festival has been celebrated in the park every year since 1976. Civic pride was being restored, and the road back from urban unrest had taken a positive turn.

Noteworthy in the history of Branch Brook Park was its placement on the New Jersey (1980) and the National (1981) Registers of Historic Places through a nomination submitted by Galop under the auspices of the festival. This action fulfilled a festival commitment to preserve and protect this very special park.

Change in the structure of the Essex County government in 1978 resulted in replacement of the Essex County Park Commission with the Essex County Department of Parks, Recreation and Cultural Affairs. Despite this change, Branch Brook Park and the park system continued to survive and to serve as the primary recreational refuge for Essex County citizens. In 1998, Essex County citizens voted to create the Recreation and Open Space Trust, which has provided funding for landscape and recreation needs of Branch Brook Park.

In 1999, the Branch Brook Park Alliance was formed, bringing together a broad base of support for the park. The Branch Brook Park Alliance has partnered with Essex County to restore and reactivate the park. The Branch Brook Park Alliance has completed preparation of a comprehensive "Cultural Landscape Report, Treatment and Management Plan" that will serve as the blueprint for Branch Brook Park into the next century.

As the park reaches this 140th anniversary milestone, park enthusiasts celebrate and recommit their efforts to the park to take it into the next century.

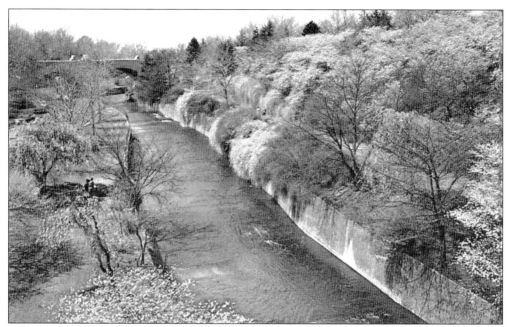

These images depict the graceful beauty of the cherry blossom trees and forsythia plantings as they spill over the embankment of the Second River. The delicacy of their blooms is showcased against a backdrop of evergreens as envisioned by the Olmsted Brothers in their planting plan for the Extension. The 1960s vintage postcard shown above presents the scene as viewed from the automobile bridge looking west into the park. The Second River, which winds through the northern edge of the park, serves as the official boundary between Newark and Belleville. In developing the planting plan, the Olmsted Brothers were attempting to create the feeling of a Japanese landscape. The solitary flowering cherry tree in the photograph presented below appears to convey exactly what was contemplated by the Olmsteds. This lovely photograph was an entry in the 1976 Newark Cherry Blossom Festival Photography Contest.

The cover of the nomination submitted for placement of the park on the state and national registers contains the signature logo of the Newark Cherry Blossom Festival. Aside from the recognition attached to placement on the registers, such placement also provides protection from actions and undertakings that could adversely impact the integrity of the park's historic landscape.

The Newark Cherry Blossom Festival challenged the nation's capital in 1976, declaring "our cherry trees are the best". Newark's legendary congressman Peter W. Rodino presented the challenge in a poem he wrote for the New Jersey State Chamber of Commerce dinner in Washington, D.C. In 2004, Rodino received the Branch Brook Park Alliance "Lion Award" for his lifelong commitment to the park. Shown here with Rodino at the 2004 Cherry Blossom Gala are (from left to right) Jane McNeill, Winifred McNeill, and Kathleen P. Galop.

Committed to enhancing the cherry tree collection in the park, the Newark Cherry Blossom Festival established the Cherry Tree Fund in 1977 to mark the 50th anniversary of the Caroline Bamberger Fuld donation. In the photograph above, festival cofounder Kathleen P. Galop joins assemblyman Michael Adubato (left) and Albert J. DeRogatis of the Prudential Insurance Company of America in planting 10 trees donated by the Prudential Insurance Company of America in the Concert Grove. In the photograph below, one of the youngest donors to the Tree Fund, Holli Giarraputo (now Francis), is seen assisting Essex County Parks Department employee Frank Mazzella with the planting of the tree she donated with pennies from her piggybank. Holli's tree was just one of 420 new trees donated by the Cherry Tree Fund and planted in the Extension in May 1979.

With a change in the form of county government in the spring of 1979, county executive Peter Shapiro appointed the first members of the Advisory Council on Parks and Recreation. Shown here being sworn in by the Honorable Alexander Matturi are (from left to right) Leo Bunion, Howard Quirk, Kathleen P. Galop, Miguel Rodriguez, and Joseph N. DiVincenzo Jr. On the far right, also being sworn in, is William Scalzo, the newly hired parks director.

In a lakeside ceremony on a beautiful spring afternoon in April 2000, the New Jersey chapter of the American Society of Landscape Architects presented its Centennial Medallion Award to Branch Brook Park. The park was one of only three designed landscapes in the state of New Jersey to receive this prestigious award, which recognizes the park as a national landmark of landscape architecture.

Historic House Tour

Forest Hill, Newark New Jersey

The park does not exist in a vacuum. It contributes as much to its surrounding community as the community contributes to the ambiance of the park. It borders the Forest Hill Historic District, which was entered on the New Jersey and the National Registers of Historic Places in 1990. The Forest Hill Community Association sponsors a historic house tour in the fall and a garden tour in the spring. Members of the association also volunteer at park clean-up days and other events sponsored by the Branch Brook Park Alliance. An earlier neighborhood group originated a Christmas tree lighting ceremony, which continues to this day, on Heller Parkway next to the tennis complex. The North Ward Center, long an anchor for the neighborhood and housed in the William Clark Mansion, sponsors youth baseball teams, which compete at the new Middle Division Ballfield Complex. In 2003, New Jersey Network Public Television produced and aired a documentary film on Branch Brook Park titled *Branch Brook Park—Legacy of the Gilded Age*. This documentary has received national distribution.

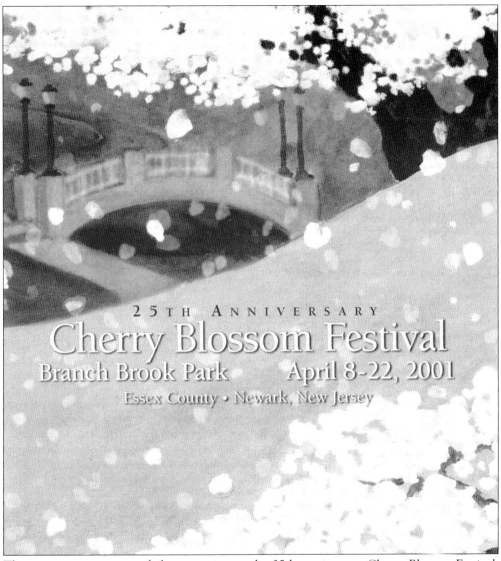

25TH ANNIVERSARY
Cherry Blossom Festival
Branch Brook Park April 8-22, 2001
Essex County • Newark, New Jersey

This romantic scene graced the invitation to the 25th anniversary Cherry Blossom Festival, hosted by the Branch Brook Park Alliance in 2001. The Branch Brook Park Alliance works cooperatively with Essex County to help restore, renew, and cooperatively assist in the maintenance of the park for the enjoyment of Essex County residents and its many visitors from around the world. In addition to raising the profile of the park, the Branch Brook Park Alliance raises funds to support the rehabilitation of Branch Brook Park and to ensure that its historic landscape design endures. In 2001, the Branch Brook Park Alliance retained Rhodeside and Harwell, a landscape architecture and planning company, to prepare the critically important "Treatment Plan" that guides future projects in the park. In addition, the Branch Brook Park Alliance sponsors an annual fishing and boating derby on the lake and initiated a successful farmers market during the summer months. The annual Cherry Blossom Gala held in April is the Branch Brook Park Alliance's major event and provides the opportunity for the Branch Brook Park Alliance to present its prestigious "Lion of the Park" Award to individuals with a history of extraordinary commitment to the park.

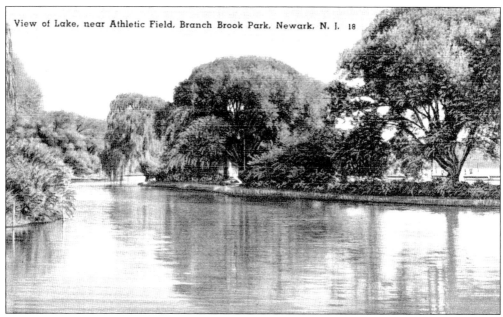

View of Lake, near Athletic Field, Branch Brook Park, Newark, N. J. 18

The historic postcard shown above looks north from the Park Avenue entrance. It presents a scene of the lake and the willows with the Middle Division Athletic Field in the right background. Active recreation has long been a tradition in the Middle Division, as evidenced by the earliest plans for this area. Today, seen in the photograph below, the Middle Division Ballfield Complex is a state-of-the-art facility providing fields for baseball, soccer, and football that are heavily utilized by youth and adults from the surrounding neighborhood. This complex represents the successful partnering of efforts by the Branch Brook Park Alliance and Essex County to create recreation fields within the historic landscape of the park. The structures built here to provide restrooms and amenities for park users complement the existing structures in the park.

Cultural Landscape Report, Treatment, and Management Plan
for Branch Brook Park
Newark, New Jersey

Volume 2: History of the Park and
Critical Periods of Development

Prepared for:

Branch Brook Park Alliance
115 Clifton Avenue, 3rd Floor
Newark, New Jersey 07104

Essex County Department of Parks,
Recreation and Cultural Affairs
115 Clifton Avenue
Newark, New Jersey 07104

In 2001, the Branch Brook Park Alliance committed to long-term restoration and reactivation of the park. To accomplish this, the Branch Brook Park Alliance retained the nationally recognized landscape architecture firm of Rhodeside and Harwell to prepare the "Cultural Landscape Report, Treatment and Management Plan" and to design the restoration. Historians Arleyn Levee and Charles E. Beveridge reviewed hundreds of original Olmsted documents, county reports, and archival photographs in developing volume 2, a detailed history of the park.

Restored entrances along the Lake Street access to the park were designed by Rhodeside and Harwell based on concepts by the Olmsted Brothers, preserving existing material elements. Graced with new signage welcoming visitors to the Middle Division Ballfield Complex, they feature elegant stonework and plantings. This project was jointly undertaken by Essex County and the Branch Brook Park Alliance, with funding from the Essex County Recreation and Open Space Trust and the New Jersey Casino Redevelopment Authority. (Courtesy of Rhodeside and Harwell.)

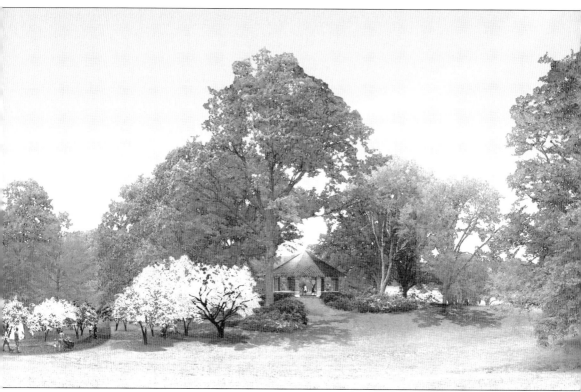

One of the earliest structures in the park was the Octagon Shelter, designed by architects Carrère and Hastings and completed around 1906. The open-air shelter stood for over 100 years on Meeker Mound, commanding a view of the gardens and lake in the Southern Division of the park. Unfortunately, the structure's roof and columns, in a state of near collapse, were removed in recent years, creating much community concern. Determined to restore this symbol of elegance to the oldest section of the park, county executive Joseph N. DiVincenzo Jr. and the leadership of the Branch Brook Park Alliance worked tirelessly to raise the needed funds for reconstruction. Shown here is the rendering of the proposed new Octagon Shelter prepared by Rhodeside and Harwell. It will be constructed according to the original plans with funding coming from the New Jersey Green Acres Program. (Courtesy of Rhodeside and Harwell.)

BIBLIOGRAPHY

The Architectural Forum, Volume XXVII, No. 1. Boston: Rogers and Manson Company, 1917.

Birnbaum, Charles A., FASLA and Robin Carson. *Pioneers of American Landscape Design*. New York: the McGraw-Hill Companies, Inc., 2000.

Bzdak, Meredith Arms and Douglas Petersen. *Public Sculpture in New Jersey, Monuments to Collective Identity*. New Brunswick: Rutgers University Press, 1999.

Church, Alonzo. *The Essex County Park Commission, A Sketch*. Newark: Baker Printing Company, 1913.

Cunningham, John T. *Newark*. Newark: the New Jersey Historical Society, 1966.

Essex County Park Commission. *Annual Reports of the Board of Commissioners, 1896–1979*. Newark: the Essex County Park Commission, 1896–1979.

Galop, Kathleen P. *Branch Brook Park, An Historical Perspective*. Washington, D.C.: National Association for Olmsted Parks, *Field Notes*, Volume 20, No. 1, 2002.

———. *Nomination of Branch Brook Park, Newark, New Jersey*. Newark: the Newark Cherry Blossom Festival, 1979.

Gasser, Henry. *An Exhibition of Watercolors to Commemorate the 300th Anniversary of the City of Newark*. Newark: the Prudential Insurance Company of America, 1966.

Kato, Kay. *Park Art with Pad & Pencil in the Parks for 31 Years*. Virginia Beach: the Donning Company Publishers, 1999.

Kelly, Bruce, and Gail Travis Guillet and Mary Ellen W. Hern. *Art of the Olmsted Landscape*. New York: New York City Landmarks Preservation Commission and the Arts Publisher, 1981.

Leary, Peter J. *Essex County, N.J., Illustrated*. Newark: Press of L. J. Hardham, 1897.

Rhodeside and Harwell, with Arleyn Levee and Charles E. Beveridge. *Cultural Landscape Report, Treatment, and Management Plan for Branch Brook Park, Newark, New Jersey – Volume 2: History of the Park and Critical Periods of Development*. Alexandria: Rhodeside and Harwell, 2002.

Schuyler, David and Jane Turner Censer, ed. *The Papers of Frederick Law Olmsted, Volume VI, The Years of Olmsted, Vaux & Company, 1865-1874*. Baltimore and London: Johns Hopkins University Press, 1992.

Wilson, William H. *The City Beautiful Movement*. Baltimore and London: Johns Hopkins University Press, 1989.

ACROSS AMERICA, PEOPLE ARE DISCOVERING SOMETHING WONDERFUL. *THEIR HERITAGE.*

Arcadia Publishing is the leading local history publisher in the United States. With more than 3,000 titles in print and hundreds of new titles released every year, Arcadia has extensive specialized experience chronicling the history of communities and celebrating America's hidden stories, bringing to life the people, places, and events from the past. To discover the history of other communities across the nation, please visit:

www.arcadiapublishing.com

Customized search tools allow you to find regional history books about the town where you grew up, the cities where your friends and family live, the town where your parents met, or even that retirement spot you've been dreaming about.

SEP -- 2017